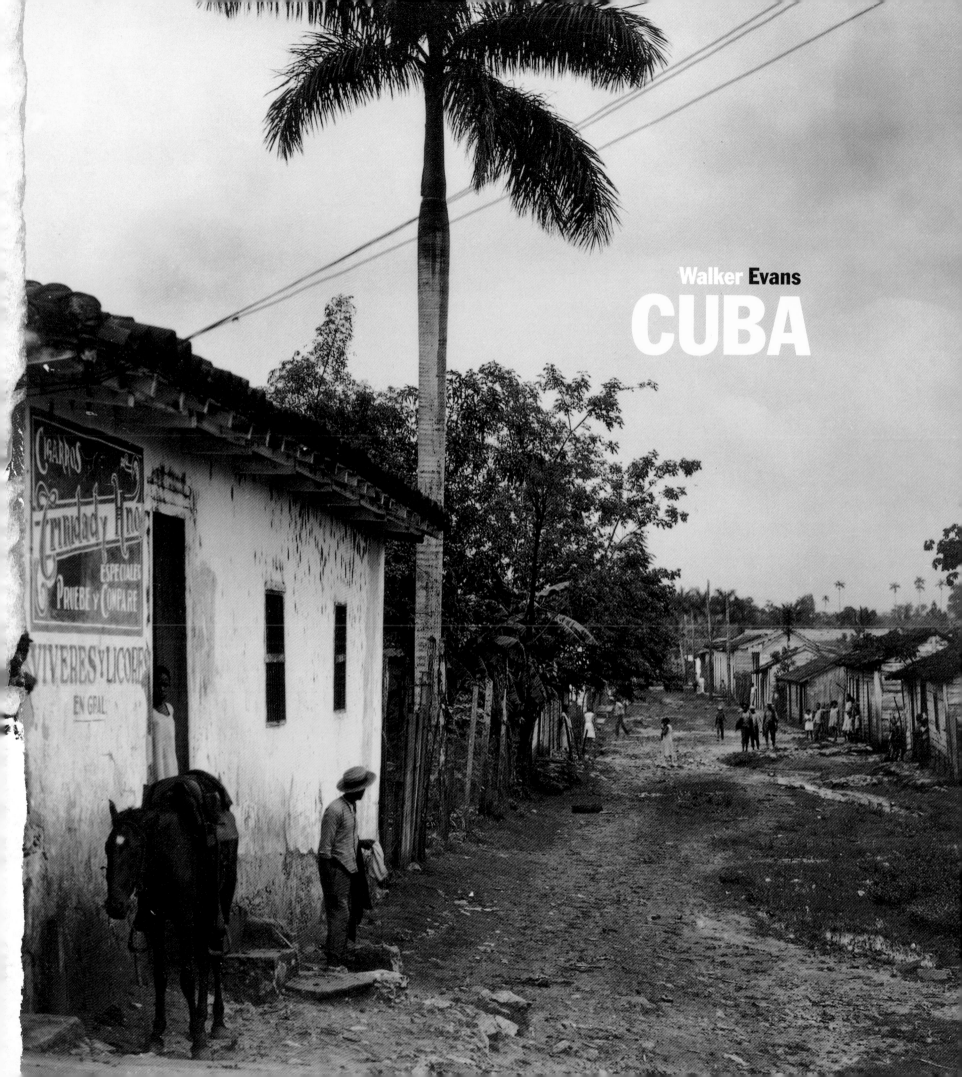

Walker Evans

CUBA

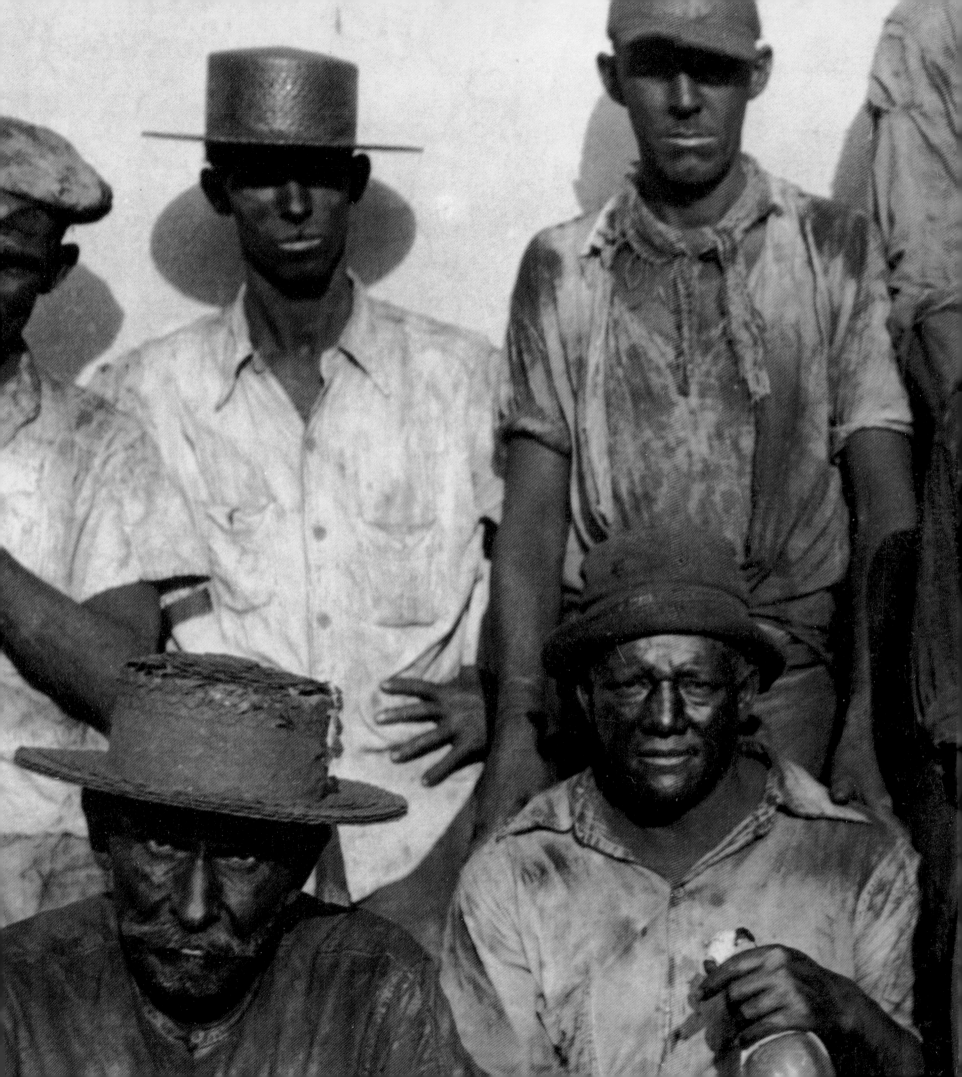

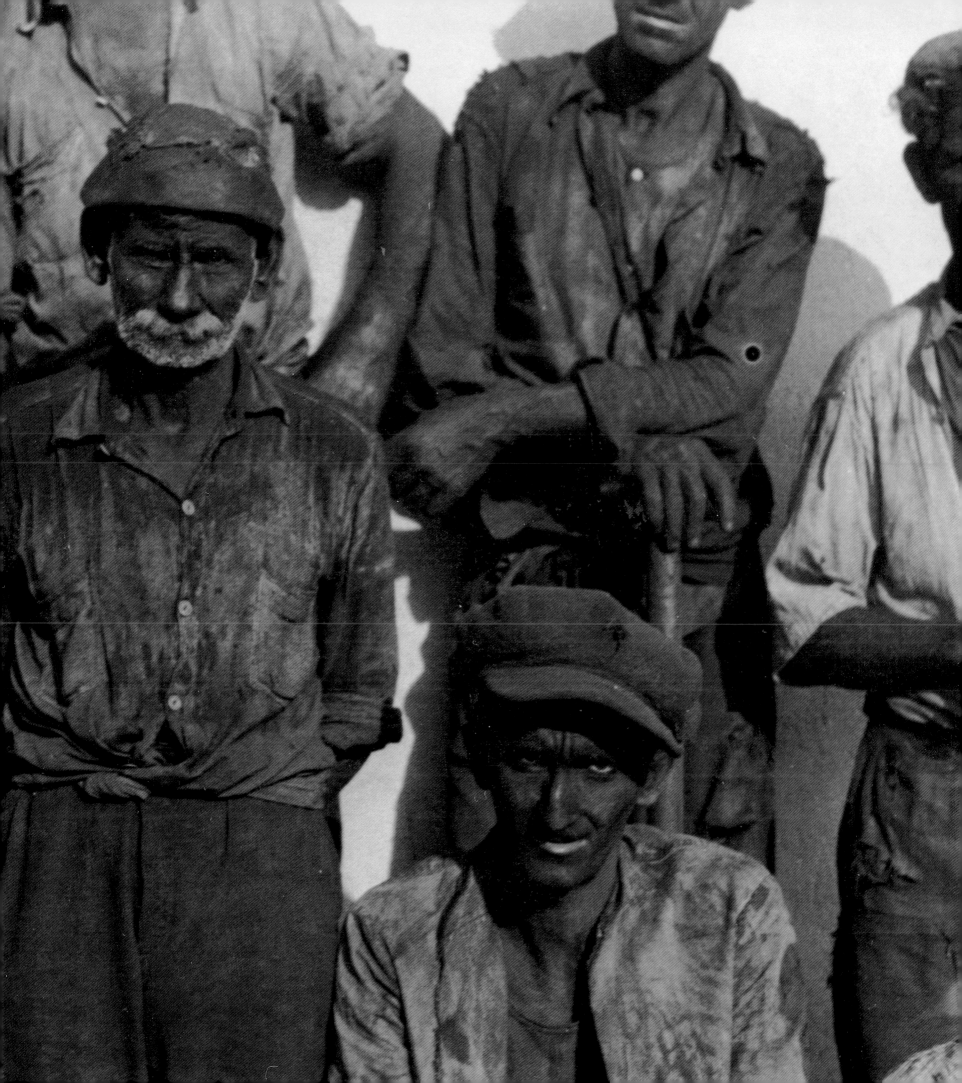

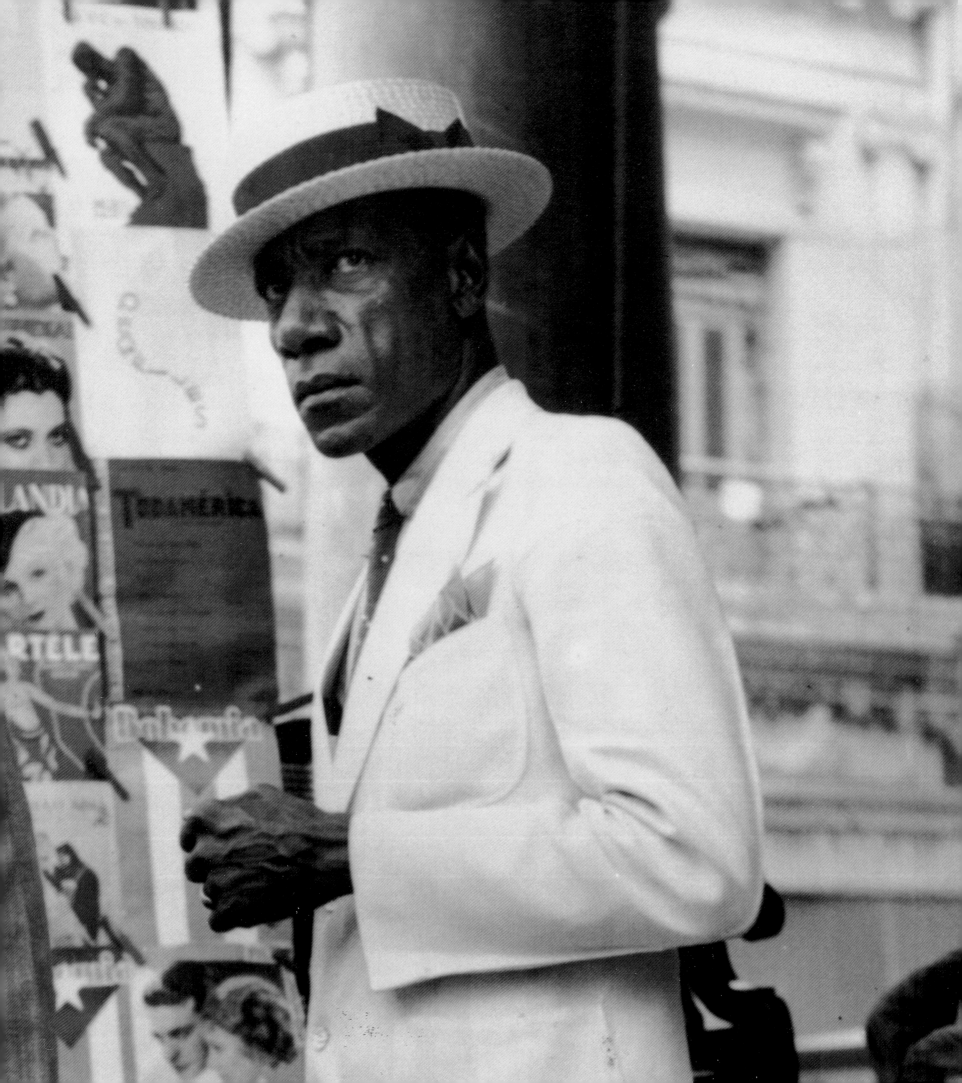

Walker Evans
CUBA

with an essay by **Andrei Codrescu**

introduction by **Judith Keller**

The J. Paul Getty Museum ☆ Los Angeles

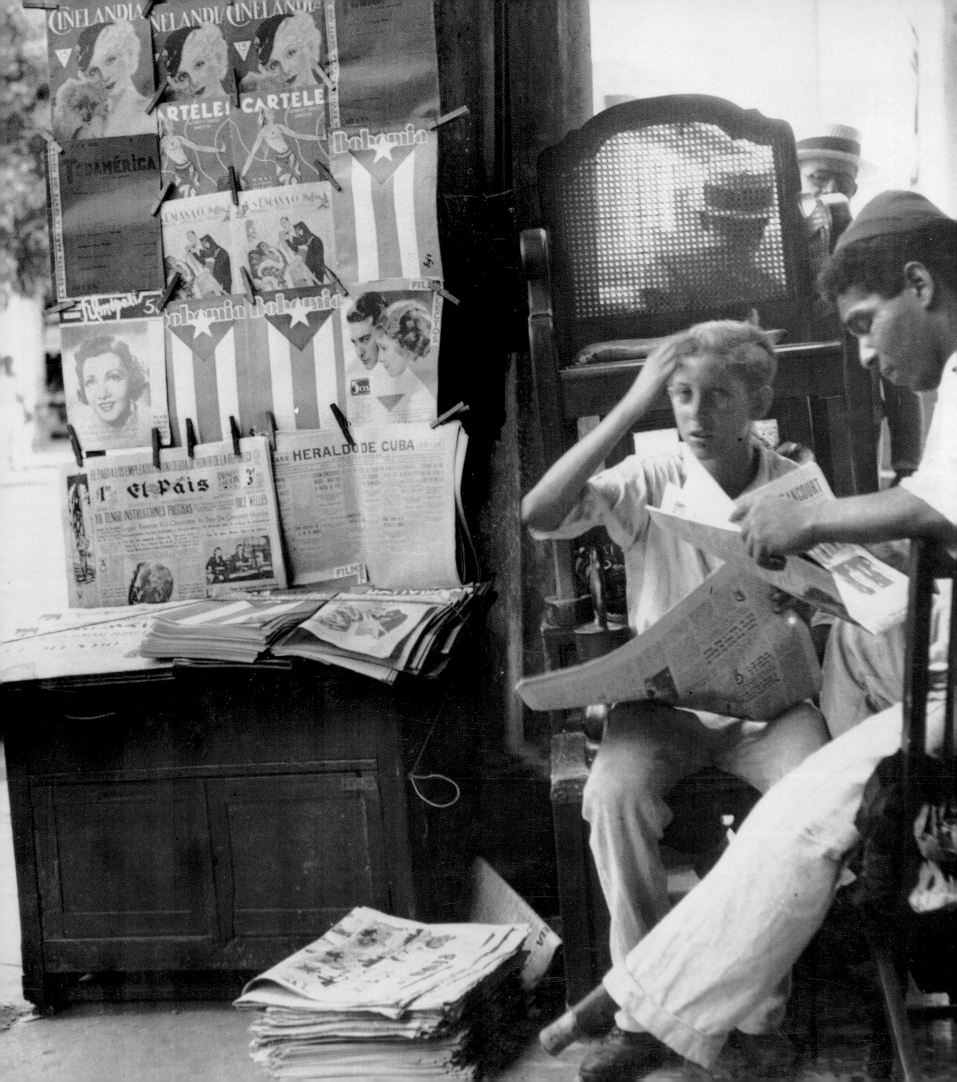

EVANS IN CUBA

In 1933 Walker Evans (1903–1975) was asked by the publisher J. B. Lippincott to produce photographs for a book about Cuba by the radical journalist Carleton Beals. Beals, who had spent the fall of 1932 in Havana, had already published three books on Mexico and had a reputation as a defender of the oppressed in Latin America. His book *The Crime of Cuba* presented a scathing indictment of the regime of Cuban president Gerardo Machado (in office from 1925 to 1933) and the long-standing exploitation of this vulnerable country by its powerful North American neighbor. Evans's photographs would be pressed into service to convey Beals's powerful message.

Evans embarked for Cuba in the spring of 1933, leaving behind a New York City that was still shaken by a controversy that had erupted over the mural painted by the Mexican artist Diego Rivera for Rockefeller Center. In *Man at the Crossroads*, Rivera had dared to include—amid iconic images of the Peasant, the Worker, and the Soldier—an image of Vladimir Lenin; in May, as Evans was preparing to leave for Cuba, the huge, partially finished mural was boarded up, and it was soon to be destroyed. The intelligentsia of New York—including Evans—quickly took sides in the controversy, which led to protests, demonstrations, and petitions. As Evans sailed for Havana, the battle over Diego Rivera's work and its socialist message would have been very much on his mind.

Once in Cuba, Evans soon made the acquaintance of the American writer Ernest Hemingway, whose *Death in the Afternoon* had appeared the year before, in 1932. Like Evans, Hemingway had grown up in a Chicago suburb, and he would be an enduring presence in Evans's life. In 1971 Evans was still musing on the influence of his friend. "Photography is reporting," he told one interviewer. "I am interested in reporting . . .

Detail of *Havana Shopping District* (pl. 25).

Hemingway was a hell of a good reporter, did it to begin with, and was always grounded in that."[1] He later said: "I met Hemingway . . . and became friends with him, and was interested in and close to his experiences. And I thought he was a sensitive and superior man. . . . he knew exactly who I was and what I was doing."[2] In these years, Evans was worried that he was "doing some things that I thought were too plain to be works of art. I began to wonder. I knew I wanted to be an artist, but I wondered if I really was an artist."[3] For a young man grappling with these questions, Hemingway's writing—with its famously stripped-down, minimal style—must have offered much-needed encouragement.

The photographs Evans made in Cuba also reveal the influence of another artist who helped shape his vision: the French photographer Eugène Atget. Evans was quite familiar with the 1930 publication *Atget: Photographe de Paris*, which he reviewed for the journal *Hound & Horn* in the fall of 1931. For Evans, Atget was a kind of naive artist who, in his obliviousness, "worked right through a period of utter decadence in photography."[4] Evans felt that Atget's photographs offered "a lyrical understanding of the street, trained observation to it, special feeling for patina, eye for revealing detail."[5] These words aptly describe the photographs Evans would take two years later in the streets of Havana.

The characteristic emptiness of Atget's photographs permeates much of Evans's Havana work, as does the earlier photographer's antiquarian sense. The series that made up Atget's study of Old Paris—for example, "Environs de Paris," "Topographie du Vieux Paris," "Paris pittoresque"—as well as his pictures of modern urban life, including the shopfronts, window displays, and signage of "Métiers, boutiques et étalages de Paris" and "Enseignes et vieilles boutiques de Paris"—seem to have served as inspiration for many of Evans's Cuban subjects: the sidewalk displays of small tradesmen, the signage of urban storefronts, the abundant street offerings of fresh produce, the decorative balconies on old houses, the many studies of archaic, horse-drawn wagons and carriages, the portraits of women who appear to be prostitutes.

The lessons of Rivera, Hemingway, and Atget that Evans put into practice during his brief stay in Cuba proved to be excellent preparation for later, larger assignments, including one from the federal government to document the details of "Middletown U.S.A." and another from *Fortune* magazine to photograph Southern tenant farmers during the Depression. These photographs would become the images for which Evans is probably best known today; a small group of them would be published in 1936 in *Let Us Now Praise Famous Men*, Evans's celebrated collaboration with writer James Agee. As Andrei Codrescu, the Romanian-born poet and essayist, so acutely points out in the following essay, these examples of Evans's mature style—the style that fostered the American Documentary movement—were, in fact, made possible by the photographer's experiences on the streets of Havana.

JUDITH KELLER
Associate Curator
Department of Photographs

1. "Walker Evans," a 1971 interview published in Paul Cummings, *Artists in Their Own Words: Conversations with Twelve American Artists* (New York: St. Martin's Press, 1979), 99.

2. "A Visit with Walker Evans," in *Images of the South: Visits with Eudora Welty and Walker Evans*, ed. Bill Ferris and Carol Lynn Yellinx, Southern Folklore Reports 1 (Memphis: Center for Southern Folklore, 1977), 29.

3. Cummings, "Walker Evans," 99.

4. "The Reappearance of Photography," *Hound & Horn*, October–December 1931, 126.

5. Ibid.

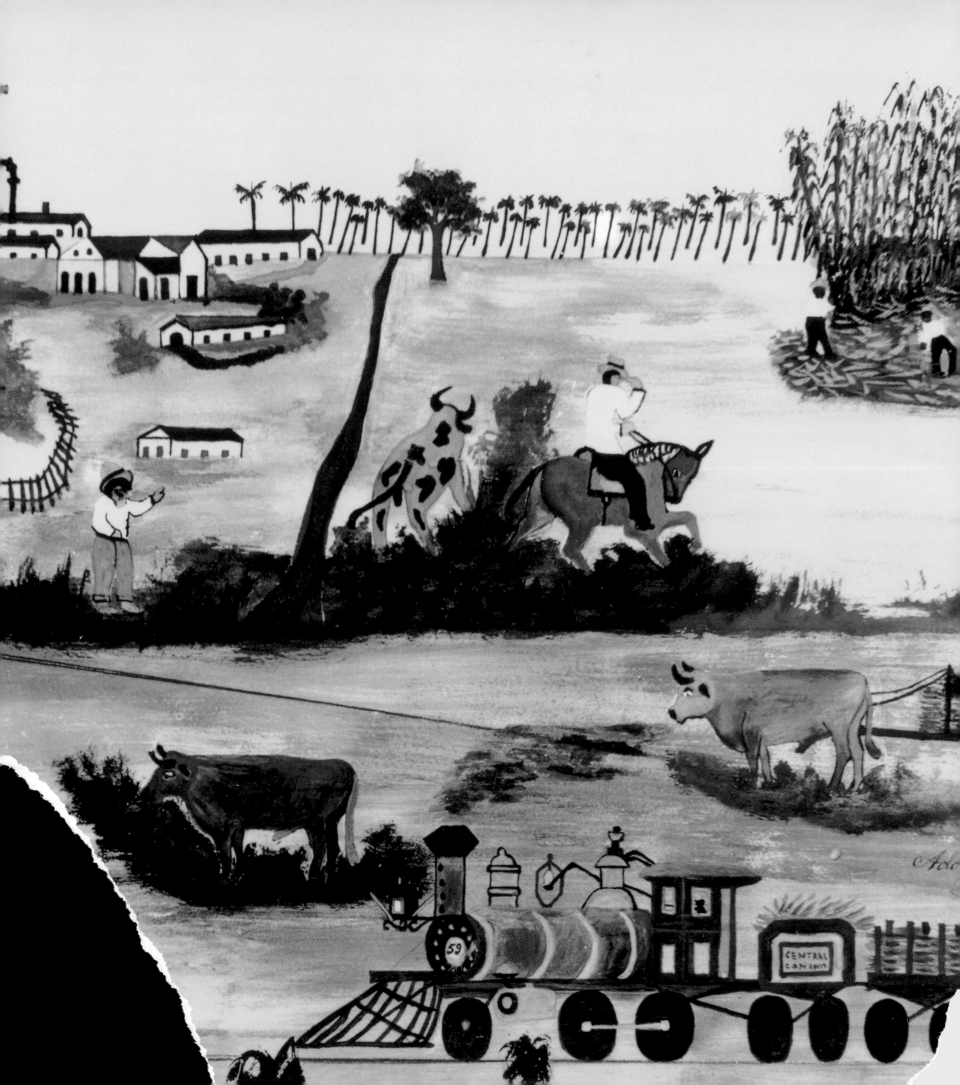

Walker Evans: THE CUBA PHOTOGRAPHS

ANDREI CODRESCU

Cuba is a nut on which many North American observers have cracked their teeth without cracking the nut. I won't even mention all the official teeth lost in the process, including those of some seriously carnivorous entities like the CIA. We have a stormy love-hate relationship with Cuba that is one of the great dramas of the New World. From the moment of Christopher Columbus's arrival in what he called "the most beautiful land human eyes have ever beheld," the story of Cuba has been one of conflict between what the eyes see and what history decrees. On encountering the native Taino who lived along the coast, Columbus professed his desire "to free the friendly, simple people and convert them to the holy faith," an intention that caused the fierce Caribs living in the interior to wipe out the gullible Tainos for collaborating with the enemy. "The holy faith" won anyway, at least on the surface, but that original conflict continued to reproduce itself in Cuban history with single-minded intensity, while the beauty of the island would remain—as we shall see—eerily present and oddly distracting.

11

Detail of *Central Conchita, Wall Painting by Adolfo Gálvez* (pl. 60).

n 1933, at the height of the age of dictators, Walker Evans went to Cuba to take photographs for a book by Carleton Beals, an investigative journalist. The assignment was a job, and while one expects Evans to have read Beals's dense factual polemic, it certainly wasn't necessary for him to do so. The obscene spectacle of sugar barons and greedy bankers robbing Cuba blind with the aid of a home-grown tyrant was the stuff of common knowledge and fodder for the newspapers. The Cuban dictator whose horrific regime Carleton Beals set out to expose and excoriate was Gerardo Machado (who—like Hitler, Stalin, Mussolini, and Perón—was known simply by his surname). Beals's intention was to show the complicity of U.S. interests with the bloody dictatorship and to generate outrage for the murders of Cuban opponents and the ruthless suppression of civil liberties on the island. Admittedly, this was not a hard case to make; even so, Beals makes it fiercely, in a style rife with the communist-fascist rhetorical excesses of the age.

Rhetorical excess was not what one associated with the Walker Evans of 1933. He was a young artist, fresh from Paris, imbued with the ideas of high modernism and determined to see America as clearly and as purely as his medium would allow. He had his work cut out for him: photography was the medium, par excellence, of an easily misunderstood clarity. Artists had already begun erecting certain barriers against the camera's all-too-obvious claim to "objectivity"; practitioners of collage, from Picasso to Tzara, were already warning against the imposture of photographs. Evans was au courant: he took such doubt for granted. His father had been an advertiser, and America was the land of advertising: literally "the land of his father(s)." The images of advertising didn't claim objectivity; they were forms of seduction. What Evans saw and cared about was America's amazingly modern cornucopia of new forms, forms that proliferated generously and continually from the hands of anonymous designers in steel, cement, and lights. He was keenly aware of the forms found in the urban repetitions of grids, layerings, crowds, advertising, and cinema posters. He discovered the flowing musical phrasing of lists, menus, and

store-window arrangements. These were most obviously elements of writing and architecture, but they also occurred as simple by-products of humans living in a city, stretching out clotheslines, setting cups on a shelf, hanging automobile tires in front of a shop. Urban geometry was Evans's quarry, an elusive subject that changed as quickly as a movie marquee or a crowd on the street. Urban geometry was temporary, unlike the geometry of nature, whose rhythms were long and boring and too still for the restless eye of his camera.

In 1933, in a highly politicized era, it was easy to confuse aesthetics with politics. Evans himself was surely in agreement with his lefty bohemian friends that capitalists were exploiting the masses and leading the world to war. There was only one other possible point of view, a fascist-romantic-suicidal-melodramatic one that repelled a sober American and (quiet) patriot like Evans. The histrionic fascism of Ezra Pound or e. e. cummings must have seemed to him like sheer lunacy. One needn't look for declarations by Evans to this effect; it is obvious from his art that he had left the romantic hangovers of Europe behind. The ideology of the left was not, however, devoid of sentimentality, notwithstanding its Marxist, "scientific" pretensions. This is evident now, but it wasn't so clear in the year of Hitler's rise to power. Not to care was almost criminal, and few modernists clung strictly to aesthetics in a world drawn starkly in black and white.

And, sometimes, in color. Shortly before Evans went to Cuba, the scandal of John D. Rockefeller's destruction of the Diego Rivera mural had the New York intelligentsia in an uproar. Rockefeller, who had commissioned Rivera to paint the mural, ordered it erased when the head of Lenin showed up in it. (Rivera, the Communist, never left home without it.) The intelligentsia rallied for artistic freedom. Everyone played their roles to perfection: Rockefeller, the evil capitalist, played the autocrat of his wall; artists, as citizens of the world, protested in the name of Lenin's head and (presumably) of the masses inspired by that head. The proletariat was probably too busy working to hear about it; Greenwich Village was very far from any coal mines or sugar fields.

In Carleton Beals's *Crime of Cuba*, all facts make a case against American imperialism. Percy Rockefeller stars, along with Harry F. Guggenheim and other magnates of the time, in the tragedy of Cuban dependence on North American interests. Beals indicts them for being both greedy and un-American. At this remove, one can hardly argue with his assessment, but it's ironic that we now know the Rockefellers and Guggenheims mainly as patrons of the arts. Walker Evans didn't have a problem with the irony: he ended up working for *Fortune*, America's premier capitalist magazine.

Within these ironies lies an interesting gloss on the photographs Evans took in Cuba. Thirty-one of these pictures accompany Beals's text. They are, for the most part, images of people, the one element missing most resolutely from Beals's writing. Beals's characters are conspiratorial ciphers who move in a world of creepy statistics and damning facts. When Beals attempts to draw a portrait, it is cartoonish: "Present was handsome young Oscar B. Cintas . . . in that mongrel oppressed world of the backward Spanish colony, people of fine physique were rare enough to excite attention. . . . His handsome bearing brightened the Woodin home." And so on. The publishers hoped, no doubt, that Walker Evans's photographs might remedy such flawed portraiture and provide a human dimension.

They must not have been pleased. Walker Evans portrayed a world of people who looked and acted modern and occasionally prosperous. The city of Havana appears vast and sexy, full of the industrial-age forms so dear to his aesthetic. Sure, there are beggars, possible prostitutes, people sleeping on park benches, and hustlers, but they could be part of any urban scene in the 1930s. There is worry on some faces, studied indifference on others, suffering in some eyes. We could be in a slower New York. Evans was fascinated with capturing people unawares, inside their private bubbles of self, even as they moved through public spaces. One can feel his frisson as he steals his picture. The young photographer valued the result to the extent that his subjects were unaware of his camera. In addition, Evans rarely photographed anybody if they were not an element of a larger

14

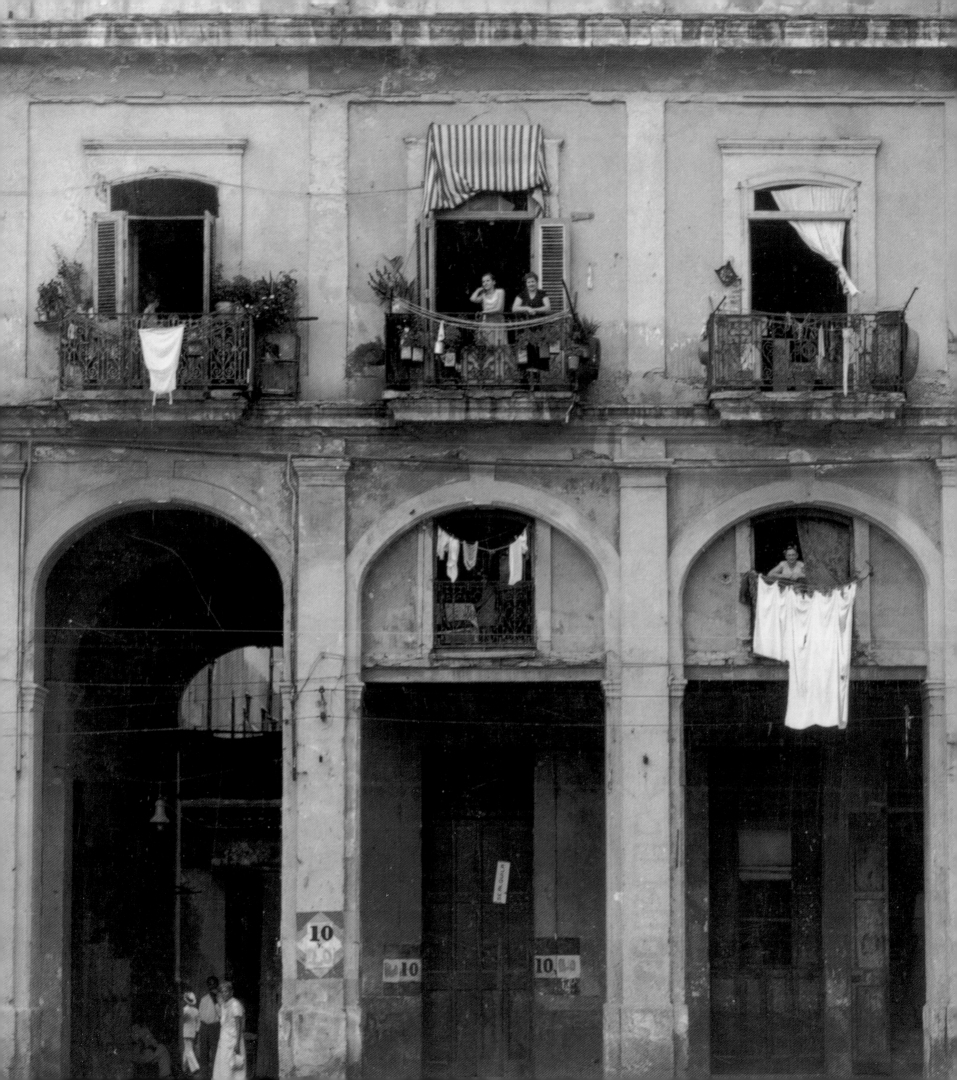

composition. His people pose within mysterious alphabets of streets and columns, between walls with advertisements on them, accompanied by various fragments of language and numbers. At this point in his development, Evans was still pursuing his occult poem through the symmetries of the modern. But there is also, barely legible, the beginning of a narrative sense and an empathy for the downtrodden that cannot yet be called "documentary" but which prefigures his future epic of Depression-era America, *Let Us Now Praise Famous Men*. In these Cuba photographs, his curiosity is still subordinate to his aesthetic intention. One can hardly speak of "compassion" or "outrage," and, in this sense, Evans's work must have been disappointing to Beals and his publishers.

The lack of outrage and horror was not entirely Evans's fault. Cuba is a finicky subject that will not let herself be surprised in an ungainly pose. In 1998 I visited Cuba with the photographer David Graham. My occasionally dark observations contrasted oddly with David's pictures. We stood, for instance, in the miserable kitchen of a poor family in Central Havana, talking with a young man about his quite desperate life. David photographed the ancient gas stove on which the young man's grandmother was boiling their clothes, and the trashy backyard with a disabled bicycle, and the toilet beside a gaping wall. These images of poverty, poignant as they were, were softened by something mysterious—the tropical light, perhaps. Everywhere we went, I saw the harshness of life under Castro's dictatorship, while David's pictures merely hint at these realities as the light and color belie them. Crumbling buildings combine with the sky to look pretty. Slum streets shimmer with ocean-salty liveliness. Skin glistens. People are wrapped in a thin coating of spicy beauty.

There are other reasons for Cuba's resistance to being captured unawares by the camera, reasons having to do with the general paralysis of the island, then (in 1933) and now, reasons that cause her citizens to move very slowly, if at all. The urban unemployed move to rhythms that are nearly imperceptible to a person with urgent business.

In effect, most Cuban citizens one sees loitering about the streets of Havana, engaged in immemorially slow occupations, like selling lottery tickets or vegetables from pushcarts, are posing. At times, the whole city seems to be posing, completely ready for Walker Evans's, or any tourist's, lens. People are, of course, posing for one another, not for a stranger's camera. The lassitude goes beyond economic despondency. The tropics shut down in the afternoon, when the sun is at its most potent, making statues of everything from people to cats and dogs. Everyone either reclines or leans, asleep and dreaming, open to any roving camera, but just enough aware to pose. They are, after all, in a public space: a space of desire.

Paradoxically, it is the empty doorways and deserted shopfronts, devoid of humans, that best suggest the vast siesta gripping the city. In *Doorway with Hanging Pots, Kitchenware Shop, Havana* (pl. 9), for instance, one can hear the snores from within, even as the pots hanging in the doorway have the potential to make a frightful clanging should a sudden breeze rise over the seawall at the Malecón. There is no breeze though, only tropical sun and a profound silence. Cinemas, butcher shops, hotels, haberdasheries, doctors' offices, and fruit markets stand silently under the early afternoon sun, floating on a sea of sleep. Evans liked photographing shopfronts at the hour of their utmost stillness, when the sun was past noon and the contrast sharp. The siesta is universal, not ideological. The rich and poor alike are napping, even if the rich have been felled by a big lunch and the poor by exhaustion. Even when there are seemingly awake people in front of their shops (like the two men seen on the following page), they are in a suspended state of waiting. After sleep, waiting is the fundamental posture of daytime Habañeros. Everyone is waiting for something to happen. They are waiting for Machado to die, for the Americans to attack, for the campesinos to revolt, for the war to end, for a new national holiday. They have no doubt that dramatic things will happen. There is no shortage of history on the island. One waits for it, and it comes, inevitably, like a hurricane out of the Gulf. The waiting people in Evans's pictures are still waiting. All that they waited for has come and gone, but there is **17**

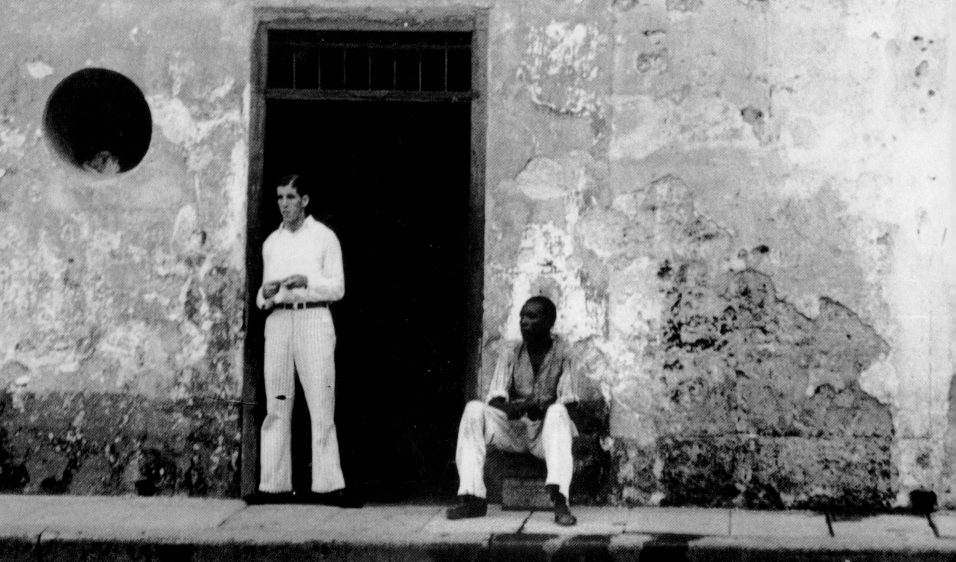

more waiting to do. Castro will die, the Miami Cubans will try to come back, the Americans might attack, the campesinos will surely revolt. The people wait. It is eerie how timely Evans's images from the Thirties remain. The text of Beals's book, righteously correct, has faded irretrievably. The cool aesthete's struggles with form remain pertinent, and alive.

By capturing the primal stillness of Cuba, Evans set up a frame for the lively agitation of the streets in the morning and in the evening, when things did happen, though not necessarily the big things, thank God. Cuban streets are stages for any number of opportunities, from sex to begging to endless minute transactions. Poverty does not limit the traffic or exchange of goods; on the contrary, it subdivides everything divisible and it gives value to every little thing. Human gestures, emotions, poses (assumed or genuine), manners of walking (from strolling to dancing)—all become part of a vast street market. And then there is the sheer expressiveness of the Cuban people who—whether handsome or not, young, old, rested, tired, urban, suburban, or country—look striking. They seem created to be photographed. I'm sure that when the exploitation, oppression, and misery stop, the Cuban people will acquire the anonymous banality of bustling moderns everywhere. Until then, they will remain what they are in these photographs: stubbornly, distinctly photogenic.

Evans knew this. He tried to photograph misery, but shapeliness got in the way. His own aesthetic did not complain as long as he didn't succumb to vividness. These are, after all, black-and-white photographs taken in a black-and-white world that was also a certifiable hell. "Black-and-white" is no mere metaphor. Those are the skin colors of Cuba, occasionally mingled, but always there, socially and politically.

Here is a young mulatto woman, posing, but not just for the camera (page 21). A white businessman across the street is furtively watching her. He is leaning against a lamppost, his briefcase at his feet, his hands in his pockets. She is looking away from him, perfectly aware of his gaze. The tension of the upcoming transaction is in the air, emphasized by a man

hurrying across the street, as if airborne on the arc of the situation. Otherwise, the street is empty: the walls are white, the doorways are black. One assumes that she is a prostitute and that the man is a john, but this assumption might belong to the Beals context. She is well dressed, in a summer dress, her sexy thighs and buttocks firmly delineated. She has a scar on her arm, a reminder of violence, but whether it's a pimp's mark of ownership or the result of an accident depends on one's reading. She is called simply *Woman on the Street*, and so she remains, in a sexy city, always posing, unwilling to surrender her identity. There is no doubt that sexual tension dominates the scene, but is it prostitution? Of course, Beals would say, America made Cuba a whore. But there is no America on this Havana street, only a sexy woman, an interested man, and an eternal tension.

Another woman looks indifferently from behind the bars over her window (pl. 21). Her arms are crossed, her lips are painted, her eyebrows sharply drawn. She, too, could be in business. There is a doorbell by the side of the window. Two vines are crossed and tied to the bars. Early travelers in the eighteenth century noted the openness of Cuban homes, whose barred windows always gave onto the street, revealing intimate family scenes. Women posed coquettishly, safe behind their bars, while strangers on the street stopped and watched them. The living room was an extension of the street, so the inhabitants of these open interiors were often dressed in their best and carefully groomed, though they took care to appear casual. This strangely protected exhibitionism had its origin in Spain, where passion and censure had a long and formalized tradition. But Havana was considerably hotter than Cádiz, so the propriety of Spain was breached by the climate and the flesh was much more present. Whether the veil-less woman photographed by Walker Evans in the 1930s is literally a prostitute or not is unimportant. Again, the photograph is entitled simply *Courtyard in Havana*. Evans makes no assumptions. Beals would have preferred, no doubt, a title like *A Woman Forced to Sell Herself at a Window Because of the Callousness of the Loan Terms of Chase Bank, Which Are Creating Widespread Misery*.

20

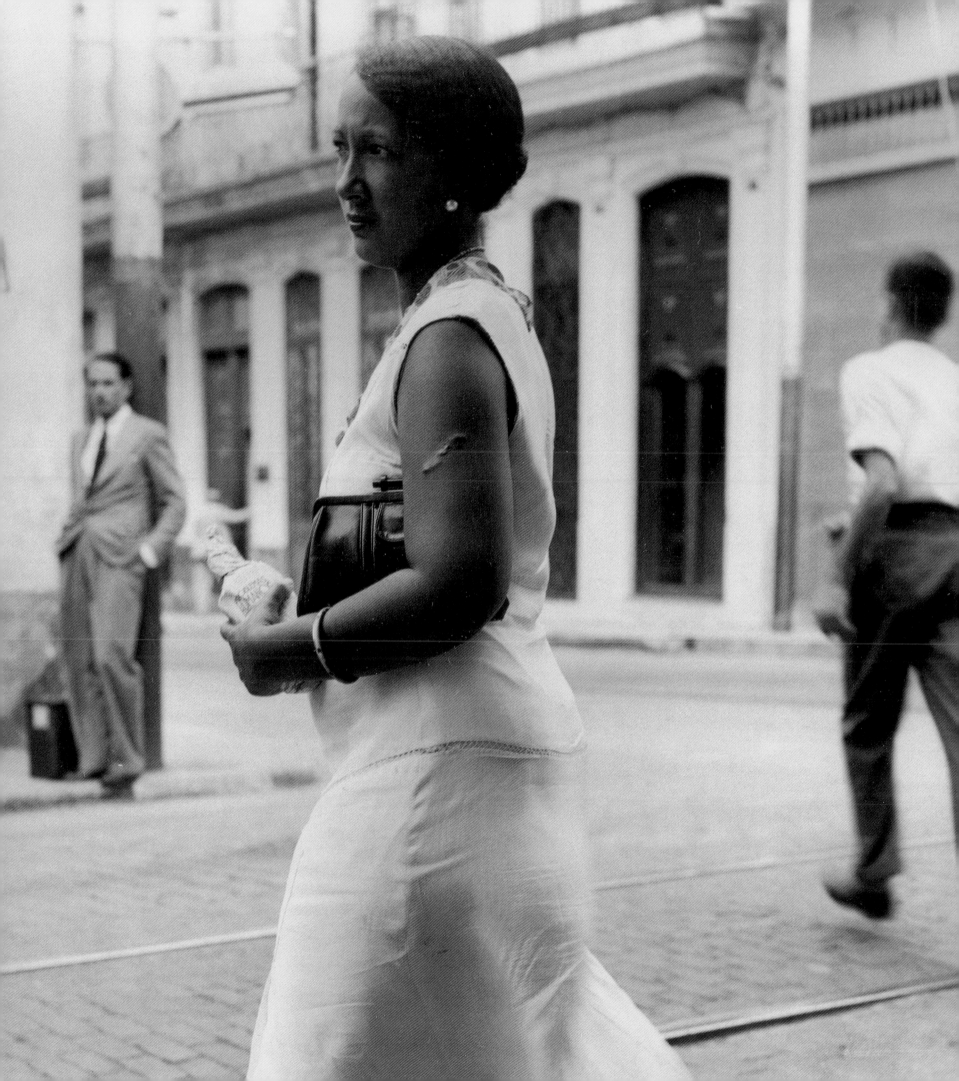

Evans's study of ambiguous Havana women continues with *Woman in a Courtyard* (pl. 22). A young mulatto woman with an unmistakable come-hither look on her face is smoking a cigarette, leaning seductively against a garbage can. She looks so much like a young prostitute I saw in the courtyard of the Hotel Nacional in 1998 that I had the strange feeling that they were the same person. Cuban prostitution in 1998 was pretty much a matter of interpretation. Young students and professionals, both male and female, swarmed around Havana tourists at night, offering their company in exchange for the entrance fee to a disco or a drink and a meal in a bar. Mixed in with this amateur crowd were a few more skilled professionals who transacted business for T-shirts and, ideally, a few dollars. Their conversation was never mercenary. Even if they asked for more than a meal, it was usually for food for their family, medicine for their baby. The unspoken assumption of race was also present. The darker girls were both more numerous and more obliging. The lighter-skinned held themselves in a haughtier manner and tried to look less interested. The erasure of color distinctions in Castro's Cuba, which is among the regime's most trumpeted "triumphs," is a myth. Evans's mulatto of 1933 is in the same predicament as the mulatto of 1998, though one assumes (at some risk) that the mulatto of 1933 was illiterate, while our contemporary had read Russian novels in Castro's educational utopia.

Risky, indeed. The street crowds milling aimlessly about Havana look just as perplexed today as they did in the Thirties. Walker Evans was a master at capturing crowds. Large groups of people satisfied his aesthetic; they surprised with their repetitions, juxtapositions, and unexpected patterns. His camera was delighted by Havana. When he photographed individuals, he preferred them on an empty stage, framed by repeating architectural detail or accidental accumulations of signage. His groups, on the other hand, are complete; they rarely need context.

In *City People* (opposite), a relatively affluent crowd mills about a passageway. Several women are looking either at a street performer or at someone bearing merchandise.

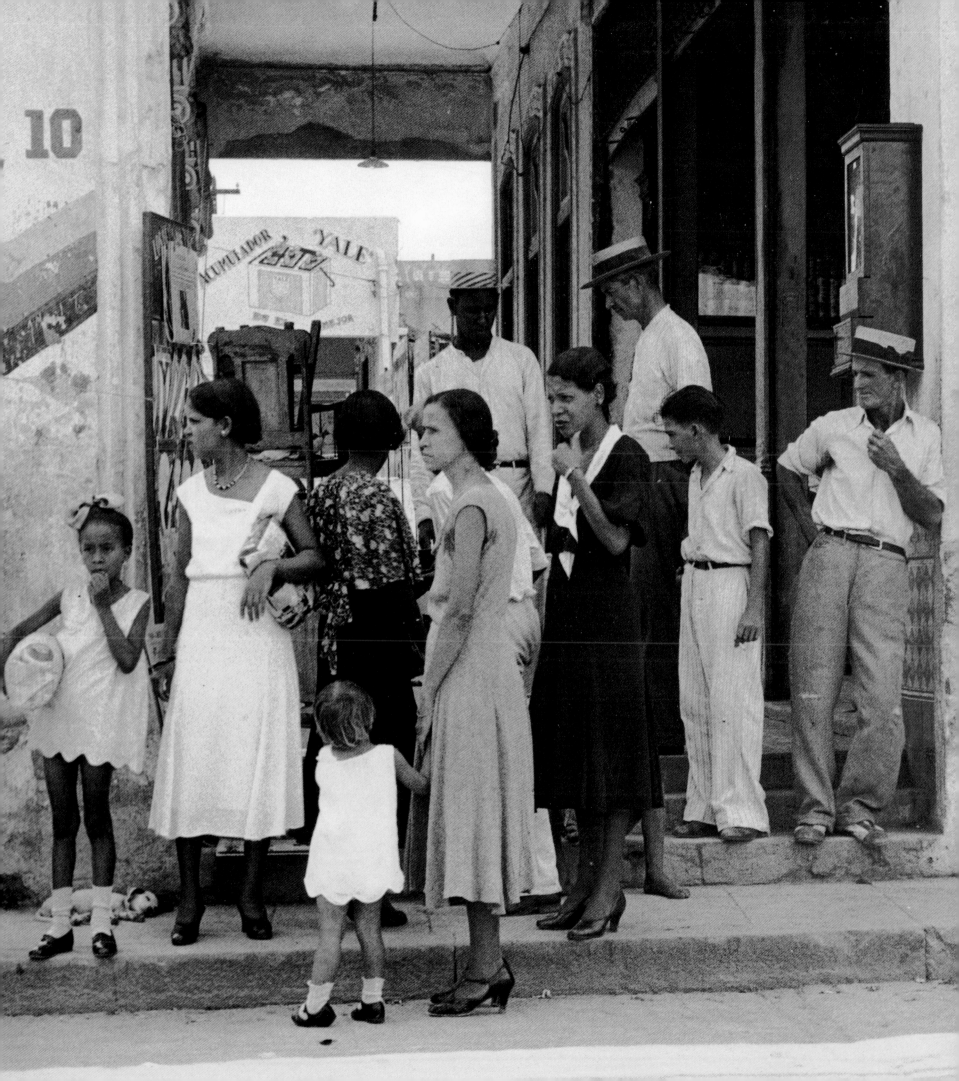

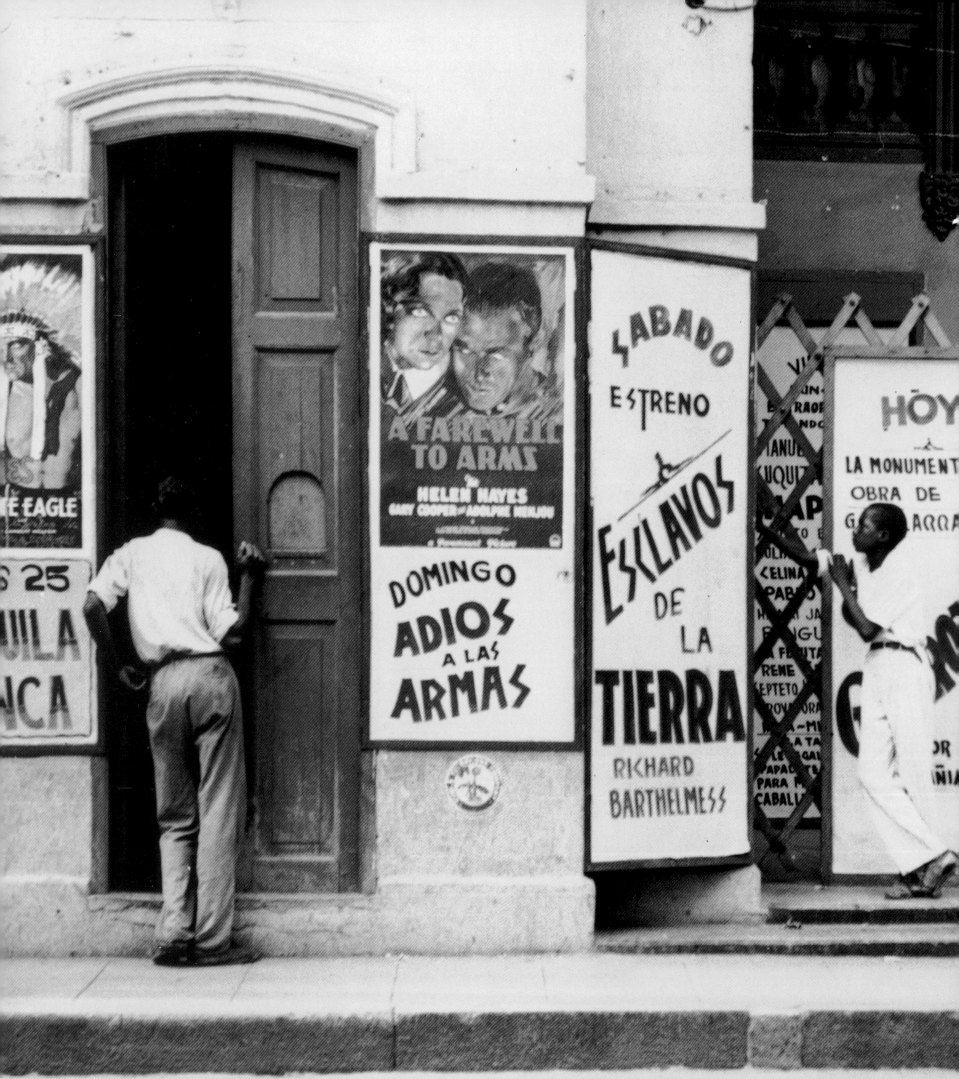

They look simultaneously intrigued and displeased. The men, wearing the ubiquitous straw hats of the period, are either watching the women or completely uninterested in whatever they are looking at. One man, leaning against a wall, has turned his back to the whole crowd and is reading a newspaper. He may even be a spy, casually listening. The group is incoherent and hard to decipher beyond a general air of expectation and boredom. But then a pattern emerges. The social status of the group is inscribed in the women's moderately heeled pumps, the children's patent leather shoes and white socks, one man's two-tones, another's half-boots. This is a racially mixed crowd, a truly Cuban palette of shades, but they are part of the same economic class. Their shoes tell the story.

The street vendors in the photograph of the same title (pl. 37) are preoccupied by their merchandise and wholly absorbed by it. Evans snapped them, characteristically, from the back, but they are not his main interest. He cares more about the oversized wheels of the pushcarts with their spokes, the patterns of the shutters behind them, the arrangement of a tiled pediment, a carved closed door. The vendors are mere human signs in an Evans alphabet.

Even when the subjects face the camera, as in *People in Downtown Havana* (pl. 30), their faces and expressions are only slightly more pronounced than the film magazine covers or posters behind them. The three men are identically dressed, while the same smiling movie-star face is visible on several covers. The pervasiveness of the cinema and the illustrated magazine fascinated Evans, but one would be amiss to read here a precocious critique of American cultural imperialism. The movie posters and newsstands interested Evans because of their reproducibility, their very mutability and transience. They were signs of urban civilization, of modern living, of city excitement. They could even possess a sly autobiographical reference: in *Havana Cinema* (opposite), Evans photographed the posters for *Adiós a las armas*, the movie version of his friend Ernest Hemingway's novel *A Farewell to Arms*, which shows on Sunday; *El águila blanca* (The white eagle), which shows

25

on Thursday; while *Esclavos de la tierra* (Slaves of the earth—a title worthy of Carleton Beals himself) shows on Saturday. A man stands between the posters, peering into the darkness of the cinema through a half-open door.

The legibility of the posters is not a new element: it is part of Evans's long textual investigation (a subject I wrote about in *Walker Evans: Signs* in 1998). Yet these Havana posters may mark the beginning of his social engagement, such as it was. I qualify this because, even at the photographer's most "engaged," there is some other activity present, a separate investigation that is mostly formal. The only difference between the early Evans, the aesthete, and the later Evans, the social documentarian, is that foreground and background exchanged places: the aesthete had the "story" in the background, while the documentarian put the story up front. In Cuba, the two Evanses were both present, though the aesthete was still in charge.

Two photographs of the same crowd are particularly relevant here. One of them is titled *Spectacle, Capitol Steps, Possibly Independence Day, May 20* (pl. 13) and the other *Public Spectacle* (pl. 12). In the first, the affluent citizens of Havana, some of them dressed for a holiday, others casual, are witnessing an official event. The crowd seems at ease, but there are tense faces and some worried, hatless people. The crowd is seen in close-up, and the intention may have been to read in their faces something about the political nature of the event or about the tragedy of Cuba. One has only to turn to Beals's book to receive the grave news and shudder. This was a country in turmoil, nearing open revolt. But nothing is legible in the individual faces, until one takes the crowd as a single organism. It then becomes apparent that this crowd is too well behaved. The hats tell the story: they are all tilted at a modestly rakish but ultimately obedient angle. And there are no women. The organism is composed exclusively of male loyalists. In the second picture, Evans photographed the same crowd from a greater distance. We now see the steps of the Capitol and well-dressed women standing behind the first group of men. The crowd is a lot sparser

than might appear from the close-up, and the organism flutters nervously. Official cars are passing before the faithful, who keep a polite distance. And one more thing: nearly everyone is white.

Now take *Havana Street* (pl. 14), another crowd scene. On a street peopled nearly as densely as the "spectacle," mobs move without an official purpose. Small groups revolve around one another in conversation, street vendors peddle fruit, children argue. There are few straw hats. Some men are bare headed, others are wearing distinctly proletarian soft hats. Nearly all are black. Some of the faces are turned smiling toward the photographer, who is perched at some height; they seem more important than the hats. One can almost see Evans trying to "tell the story" or, perhaps, to tell the story another way.

In *Cuban Breadline* (pl. 19), several women, children, and one old man are waiting before a gate for the welfare office to open. We see mostly the backs of their heads, with the exception of the old man's profile. They look hungry but not anxious; their postures are dignified. The old man looks chiseled from some stoic substance, and he may well be looking with some interest at the young woman in the foreground, whose shapeliness is not obscured. One of the children is whispering something terribly important to the other, who listens intently. Even here, forces other than basic need are in play.

Havana Country Family (pl. 18) depicts a family that had migrated to the city, most likely from what Habañeros call the "Oriente," or the east, which is used even now by Habañeros in a derogatory fashion. This tired family, politely holding hunks of bread, stands waiting for the photographer to finish. The small boy on the left can't wait to get to his bread, but his firm expression of determination and respect for the stranger are stronger. These poor campesinos may be homeless and hungry, but they are keenly aware of the world around them. They are destitute but far from broken. We are now in the presence of the future Walker Evans: this photograph could have been part of *Let Us Now Praise Famous Men*.

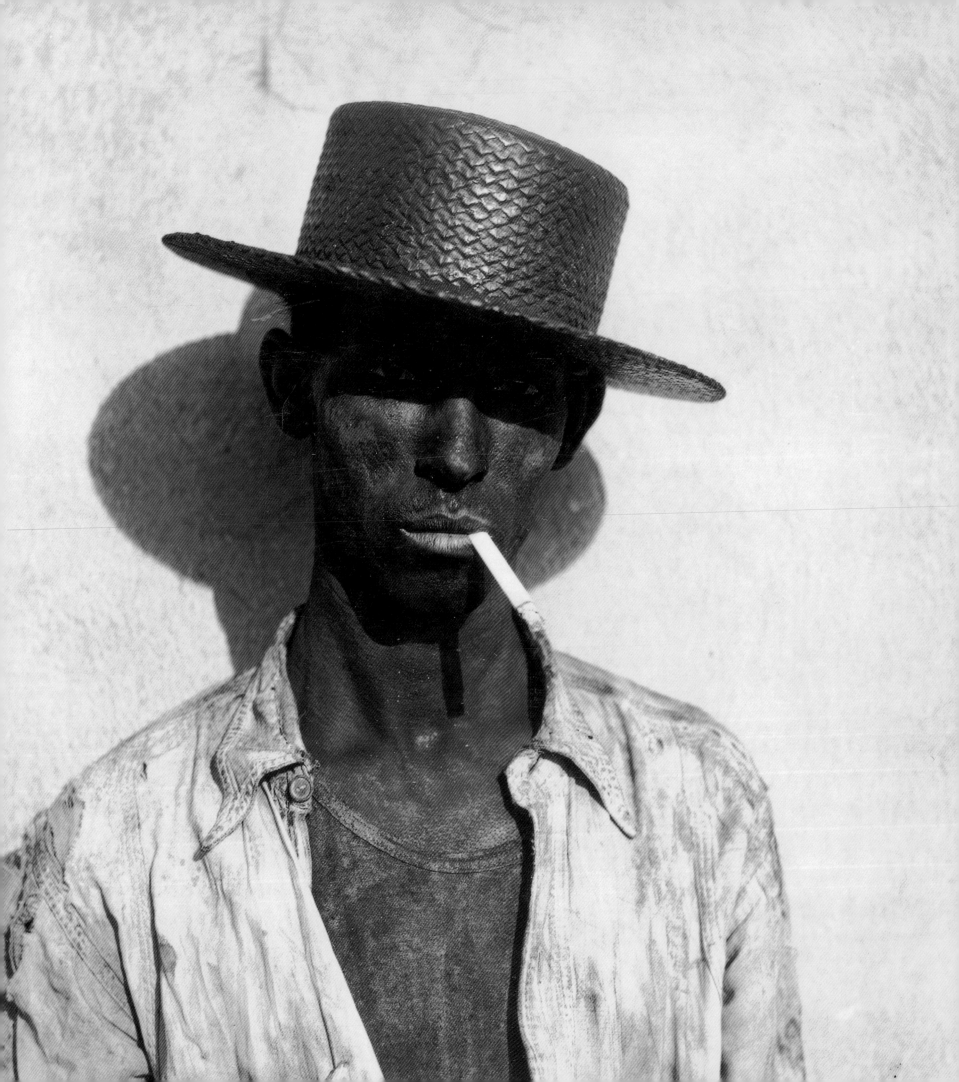

There are other such images. The most remarkable is *Coal Loader, Havana* (pl. 33), the portrait of a coal-blackened old man who is both immensely tired and fiercely determined to show the camera all that he is and every one of his countless wrinkles. Dignity is likewise the essence of the man portrayed in *Havana Stevedore* (pl. 35), who is an ostensibly more cheerful character with a hidden reserve of strength and cunning. Another coal stevedore (opposite), with a long white cigarette stuck in the corner of his mouth, is neither accommodating nor hiding; he is all distrust and defiance. The stevedore smoking a cigar (pl. 36) is none of those things. He is sexual and dangerous. The Havana peddler (pl. 27), linked to the others by the eternal cigar, has nearly shut down; his eyes are closed, his hands are joined in a last-ditch effort at self-containment. *Citizen in Downtown Havana* (pl. 23) captures a sexually charged character who embodies the whole libidinal economy of the Havana streets. He looks menacingly and seductively at the camera, with a news-stand behind him, the consummate urbanite. What is he? A bookie? A hustler? An agent of the police? A Machado spy? His presence exudes danger and desire, yet he is a worker, too, a part of the same proletariat as the hardworking stevedores. He is also someone straight out of the newspapers behind him, someone who either was or is going to be a censored news item, a *fait divers* among other censored news of strikes and assassinations. Machado's censorship in the Thirties, like Castro's censorship now, had the odd effect of making everyone look potentially suspicious, a fact that gives all photographs a certain "newsy" quality, though Evans avoided that kind of thing in his own work. (He did pursue the ephemeral text of the city in posters and signs and the occasional political slogan scrawled on a wall [pl. 16], but his intentions were cabalistic; the text is a subtext.)

The destitute, asleep on park benches or begging on the street, are on the bottom rung of the humanity that Evans photographed in Cuba. In *Parque Central II* (pl. 31), a man sleeps in an uncomfortable metal chair in a public square, his head propped on his arm. Even here, destitution is not the only story, though it is certainly the main one.

29

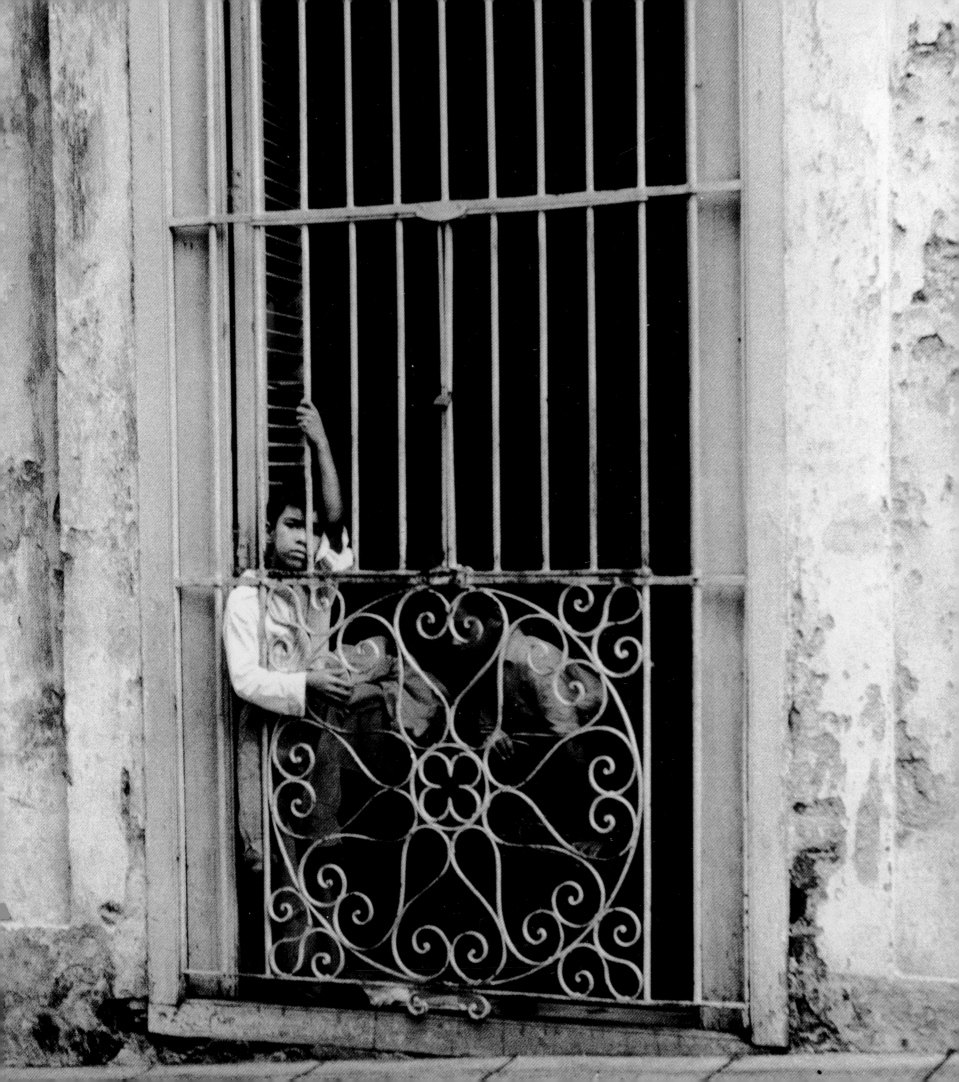

The arms and legs of the chairs link with a certain kind of weathered elegance, and the slats cast interesting shadows. It is as if Evans can't help noticing these things. The beggar in the photograph of that name (pl. 29) holds out his hand and displays a scabrous bare foot as the indifferent half of a woman with good legs goes by. A woman and her three children occupy a sidewalk (pl. 17), yet another image that anticipates Evans's work of a few years later in the American South. Two of the children are stretched out asleep on the street, while the woman holds a baby in her arms. Her look of utter despair needs no comment. Behind her is a shut door.

In these photographs, something of Beals's message comes through in the correct rhetorical way, namely, that Havana's indigent are not self-destructing alcoholics or drug addicts but truly poor people without prospects, destroyed by a cruel system. They hang on to whatever dignity they can muster, but Machado's Cuba has doomed them.

Evans's interest in the architecture that framed its inhabitants occasionally reveals the decidedly non-Marxist presence of an exacerbated religious faith. Beyond the geometric abstractions of the city's roofs (pl. 2), colonnades (pl. 3), and intricate iron grilles (opposite) lay the mystery of Baroque excess. To Cubans, adoring God means literally to "adorn" Him or, more often, Her. The image of the Virgin, exalted here as it is in most of Latin America, is a source of miracles and a living presence. Evans photographed a Virgin and Child (pl. 5) ensconced like precious stones within a frame of such overwhelming decorative abundance one expects to see miraculous tears.

Within this cornucopia of formal elements, Evans sought an emotional content that sometimes eluded him. He found it at times in the portraits of individuals whose range of expression, from fierce presence to nearly extinguished humanity, gave his work the social bite that everyone would later associate with Walker Evans, Depression Chronicler. Cuba's streets, buildings, slums, peddlers, and beggars were almost irresistibly photogenic. Evans didn't care for the picturesque, but it snuck in anyway. His camera stayed away from

beaches, but the sea is nonetheless present. Sometimes the streets feel salty; the people look only temporarily clothed.

In searching for a method to tell a story, Evans was doing more than attempting to please his employer. He felt, as anyone even half-awake in 1933 must have felt, that the world was going to hell. While many other artists of the time were questioning their aesthetics, their motivations, and, indeed, their whole raison d'être, Walker Evans was looking for a way to make his sensibility speak more clearly. The only thing standing in his path was the duplicity of photography itself, which creates expectations of "objectivity." In Cuba, Evans sought to reconcile those expectations with his particular way of seeing. He photographed everything and, in so doing, found a way.

Plate 1. *Roast Pork, Country Style (Self-Portrait)*

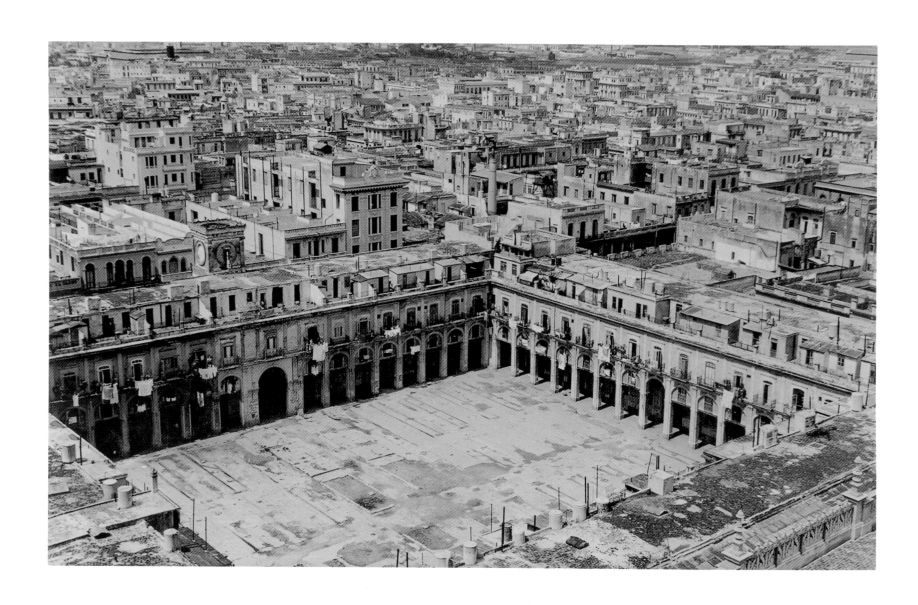

Plate 2. *View of Havana (Plaza del Vapor, Market Area)*

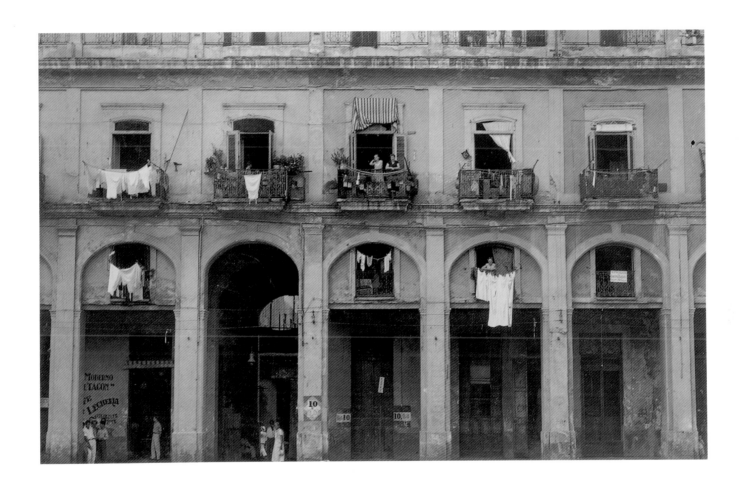

Plate 3. *Interior of Plaza del Vapor*

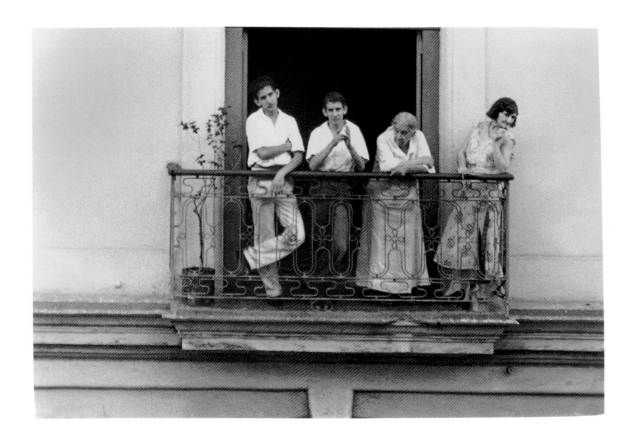

Plate 4. *Balcony Spectators, Detail*

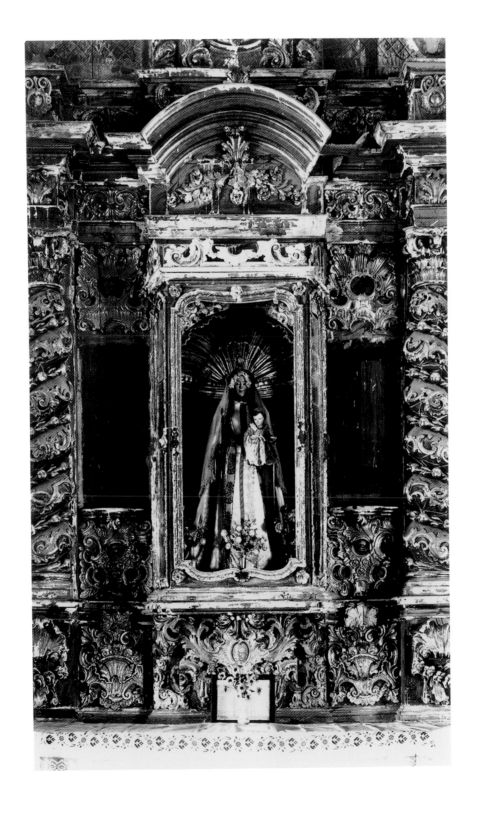

Plate 5. *Cuban Religious Shrine*

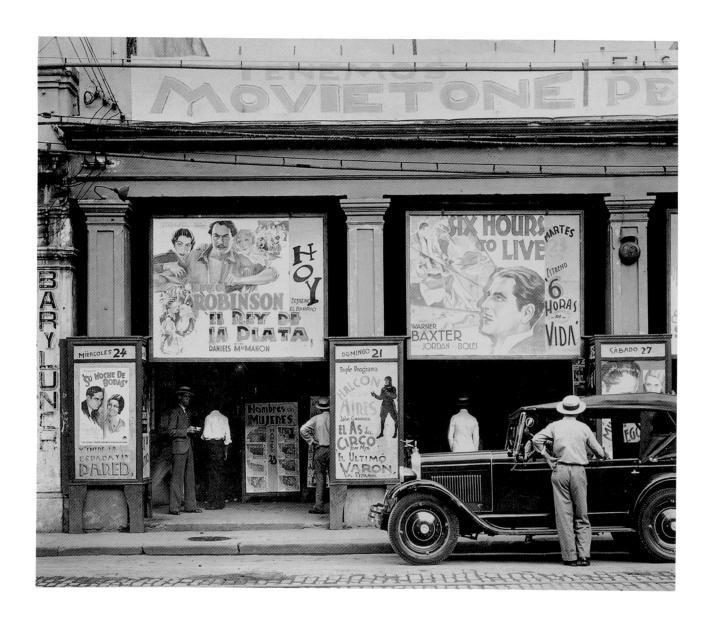

Plate 6. *Cinema*

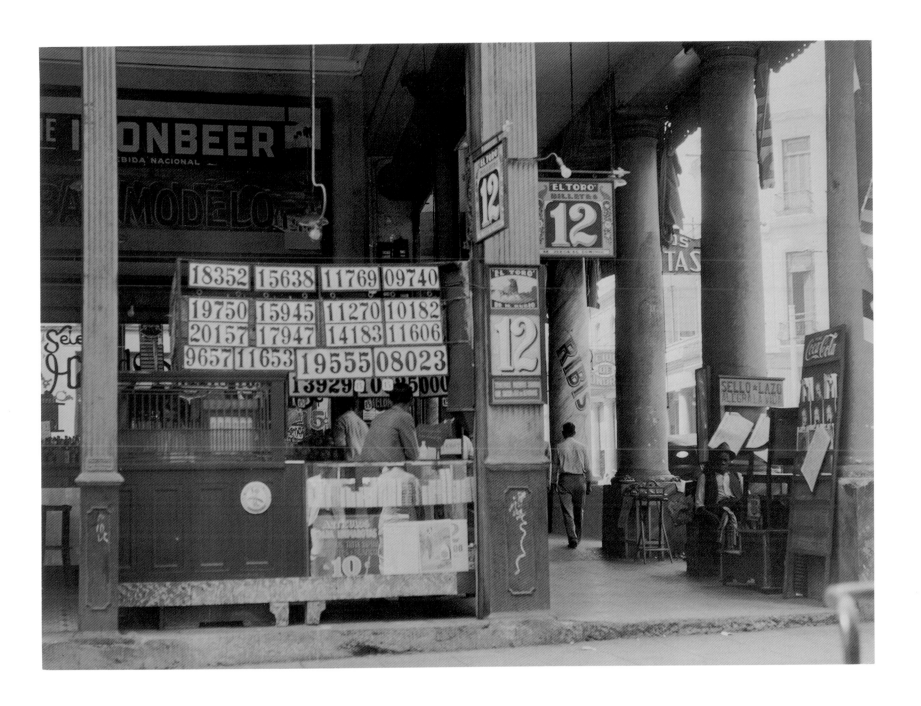

Plate 7. *Colonnade Shop, Havana*

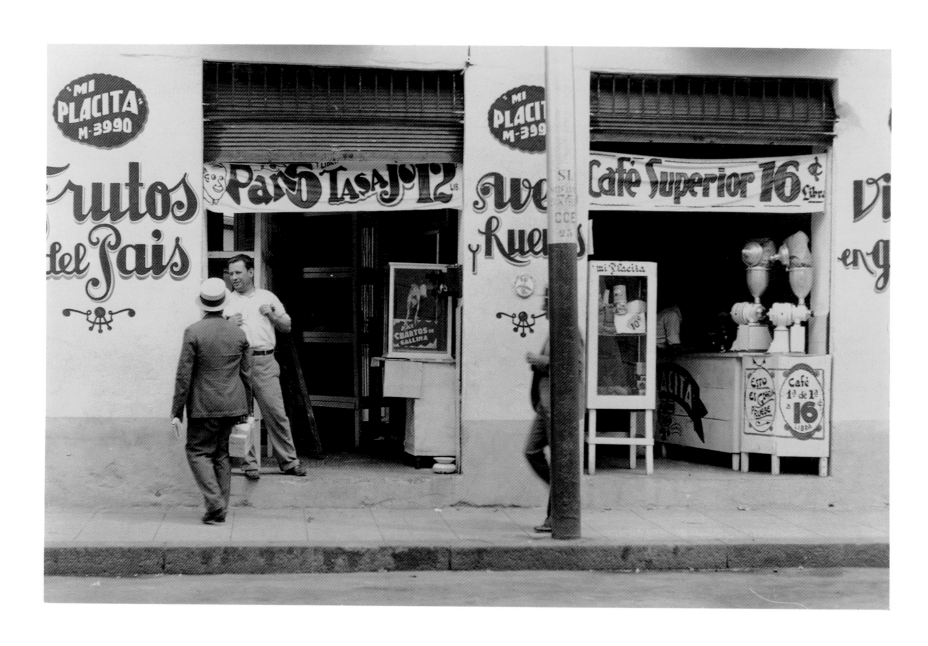

Plate 8. *Havana Shopfront* **Plate 9**. *Doorway with Hanging Pots, Kitchenware Shop, Havana*

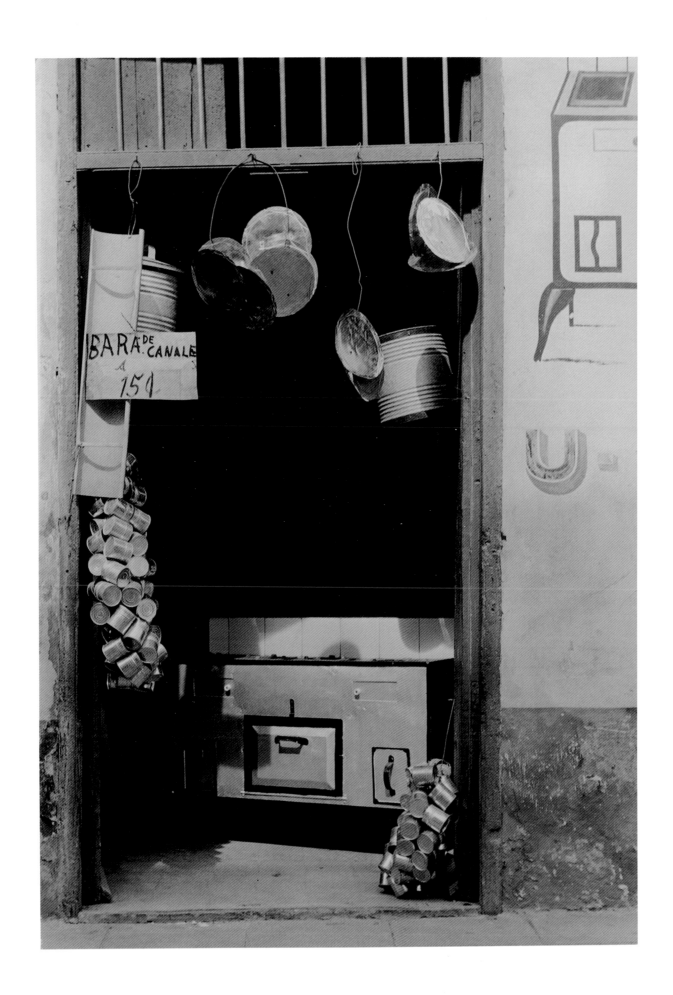

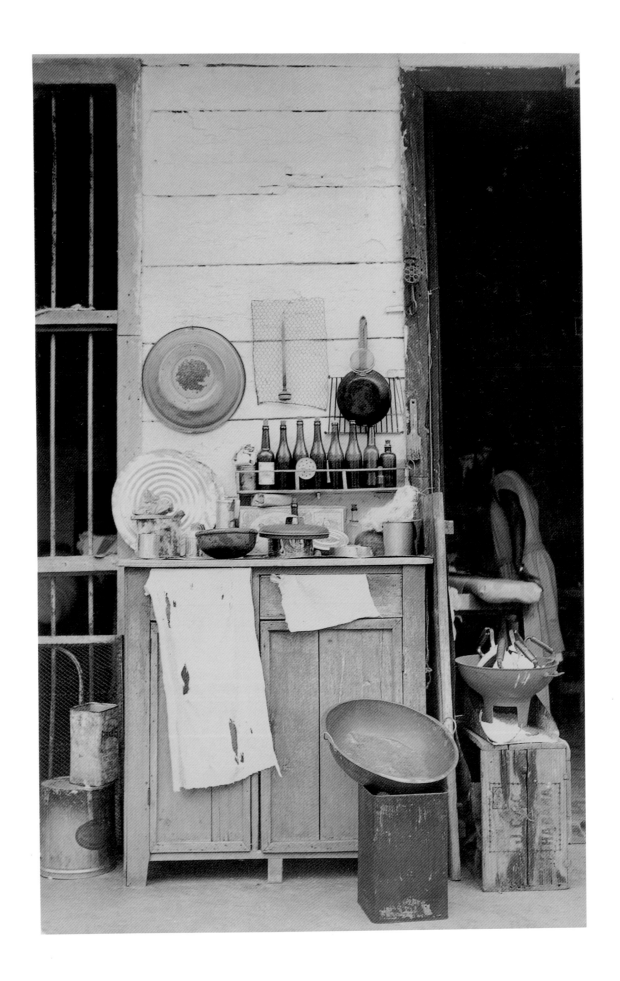

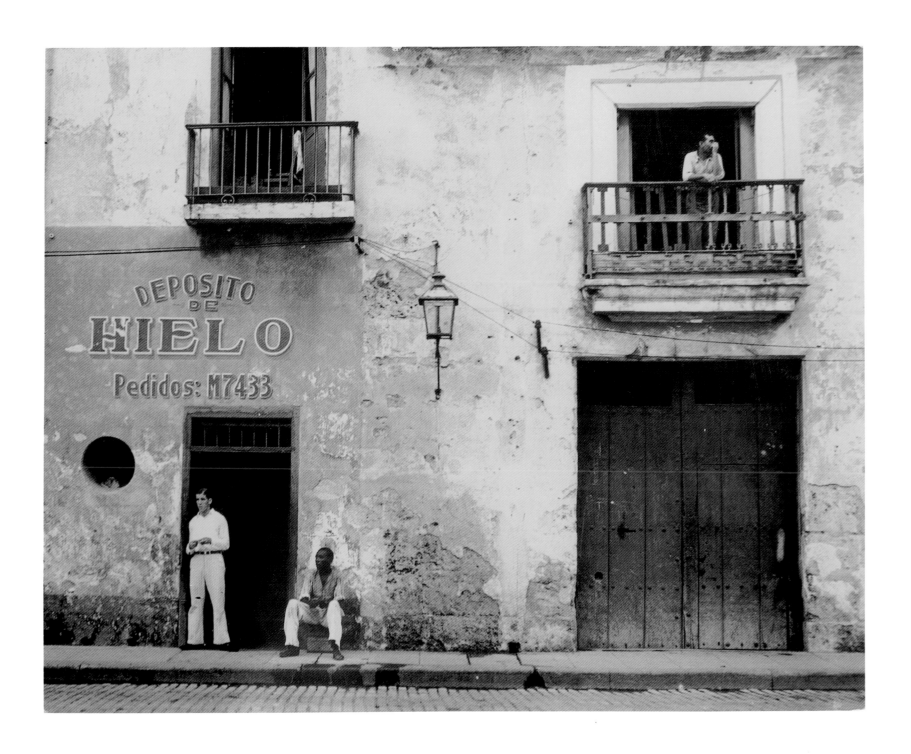

Plate 10. *Cuban Courtyard Kitchen* **Plate** 11. *Old Havana Housefronts*

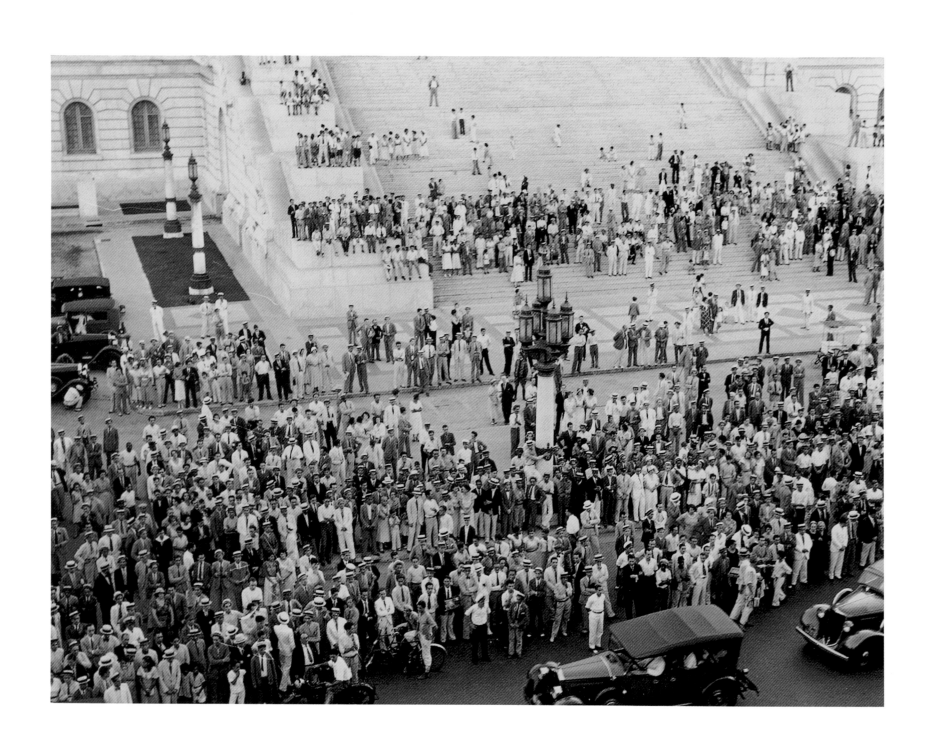

Plate 12. *Public Spectacle*

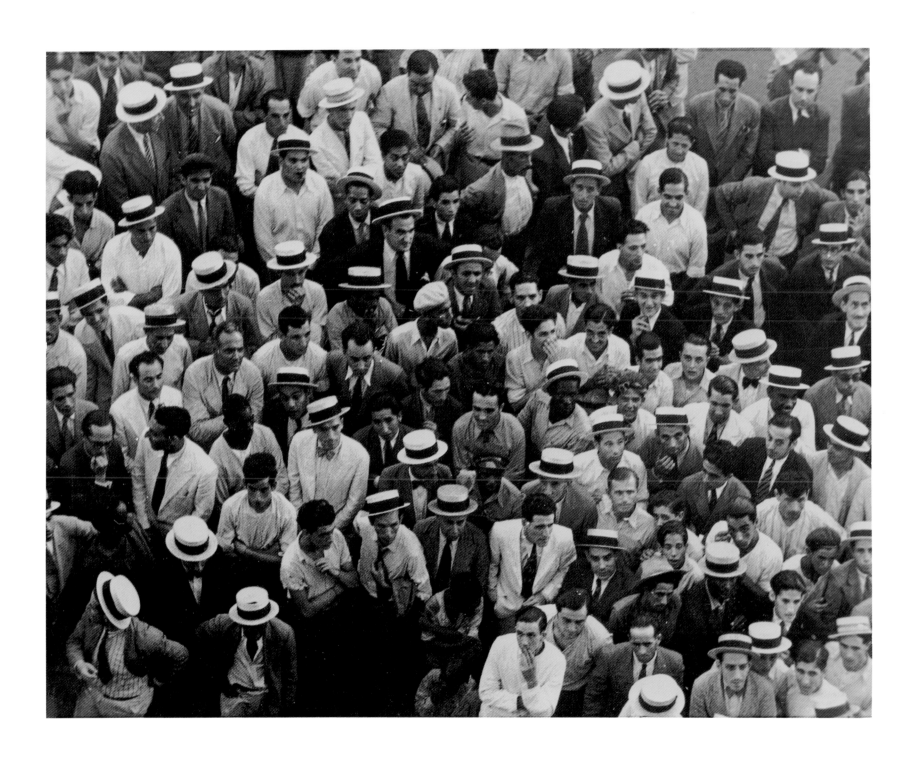

Plate 13. *Spectacle, Capitol Steps, Possibly Independence Day, May 20*

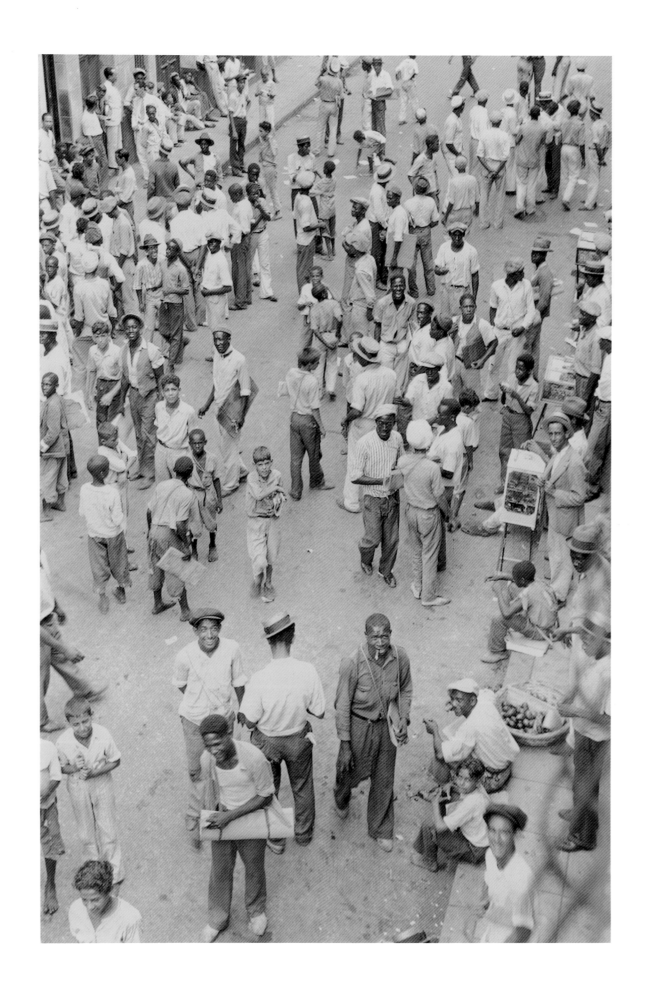

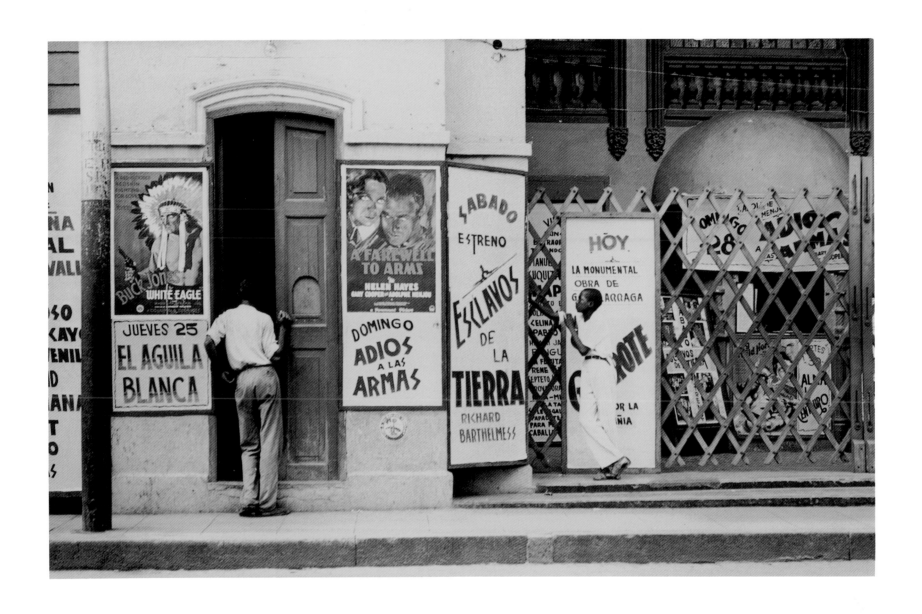

Plate 14. *Havana Street* Plate 15. *Havana Cinema*

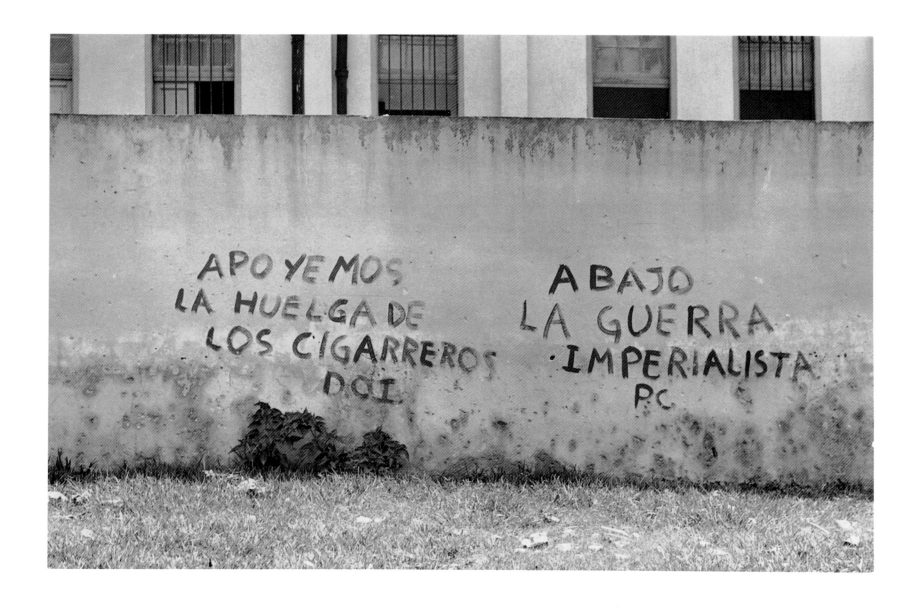

Plate 16. *Wallwriting. We Support the Strike of the Cigar Workers. Down with the Imperialist War.*

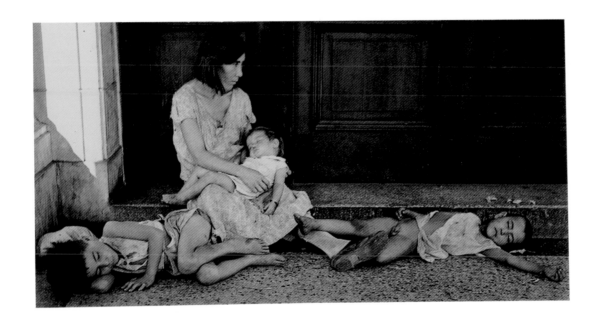

Plate 17. *Woman and Children*

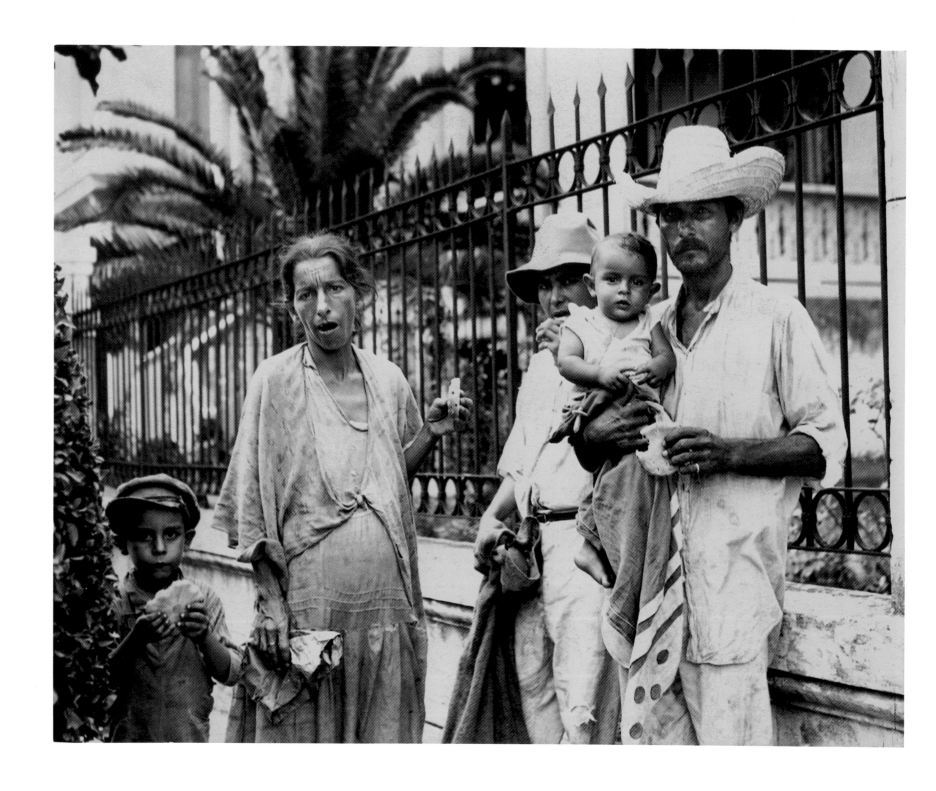

Plate 18. *Havana Country Family*

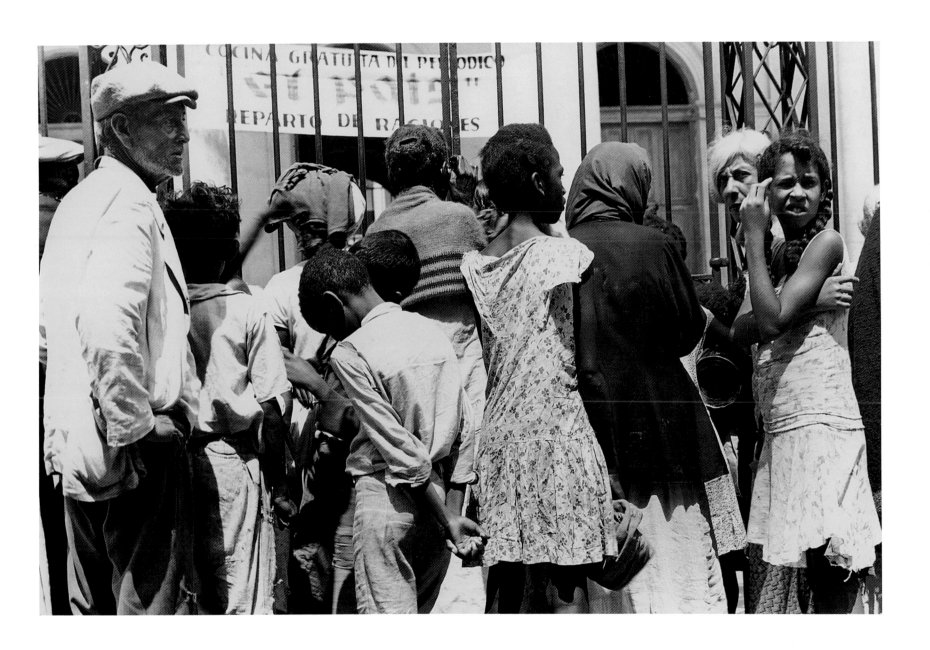

Plate 19. *Cuban Breadline*

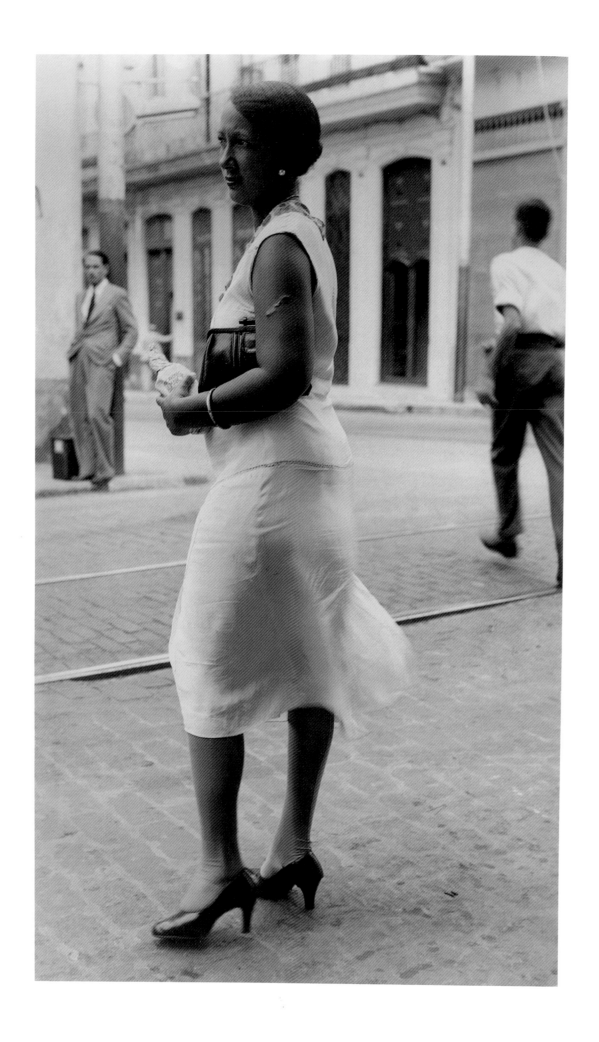

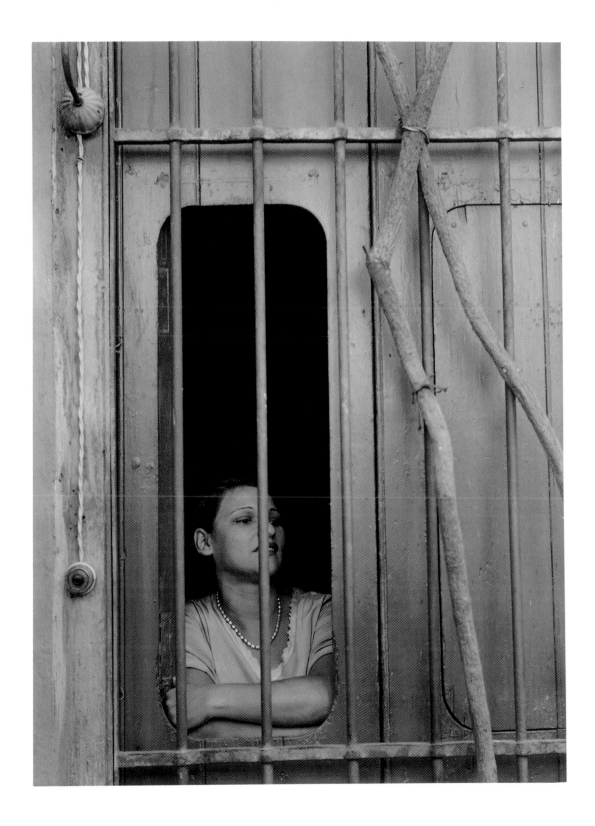

Plate 20. *Woman on the Street, Havana* **Plate 21**. *Courtyard in Havana*

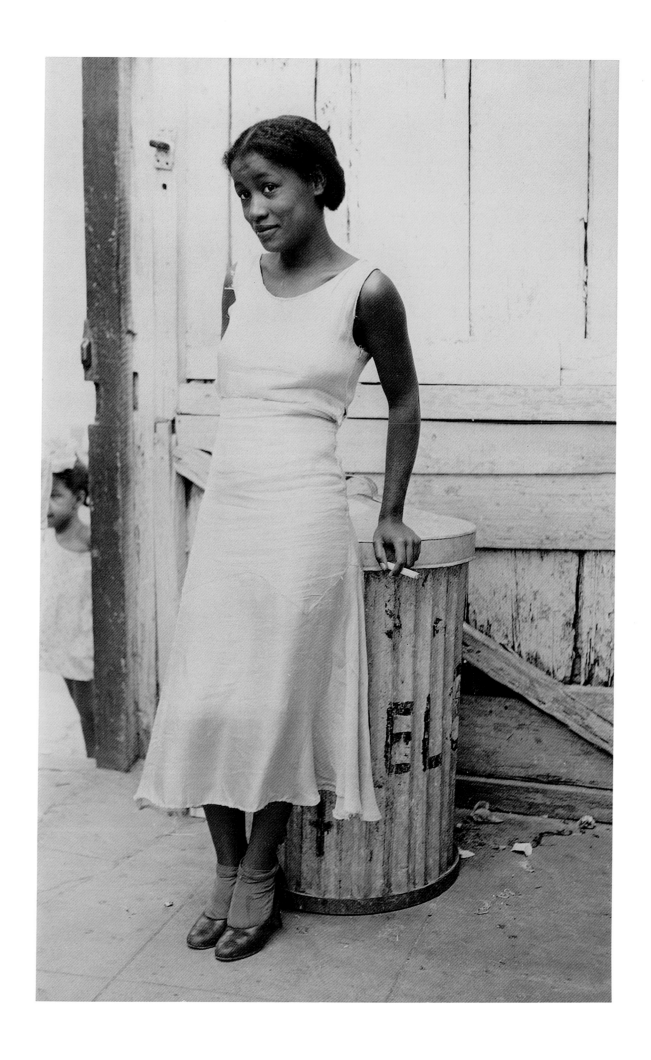

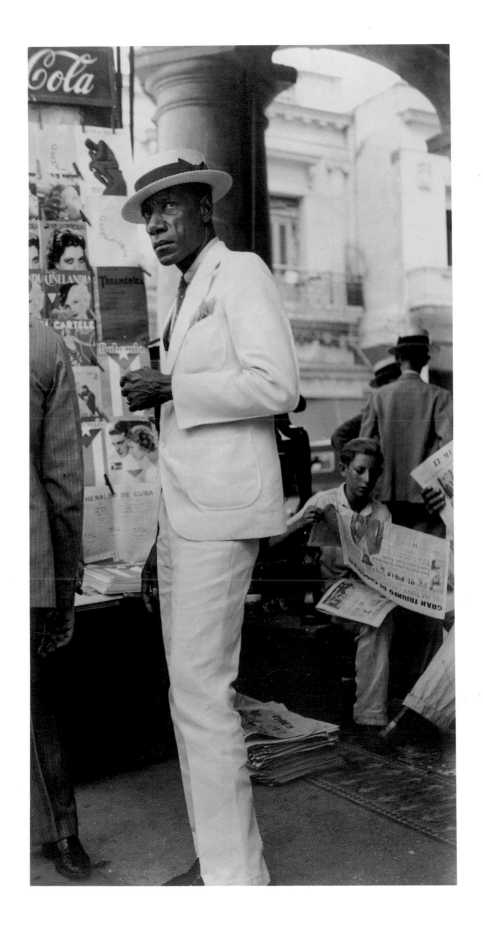

Plate 22. *Woman in a Courtyard* Plate 23. *Citizen in Downtown Havana*

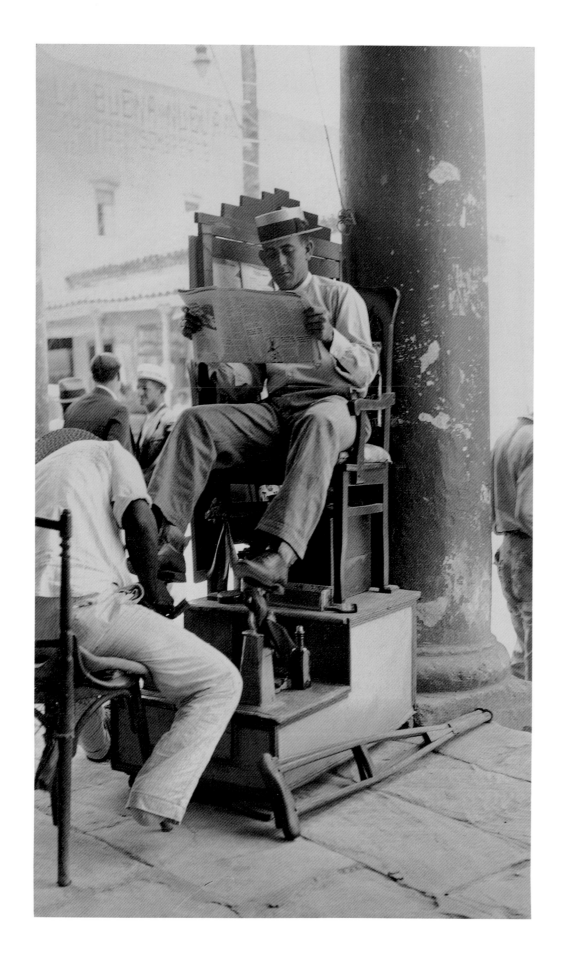

Plate 24. *Bootblack Stand, Havana* **Plate 25.** *Havana Shopping District*

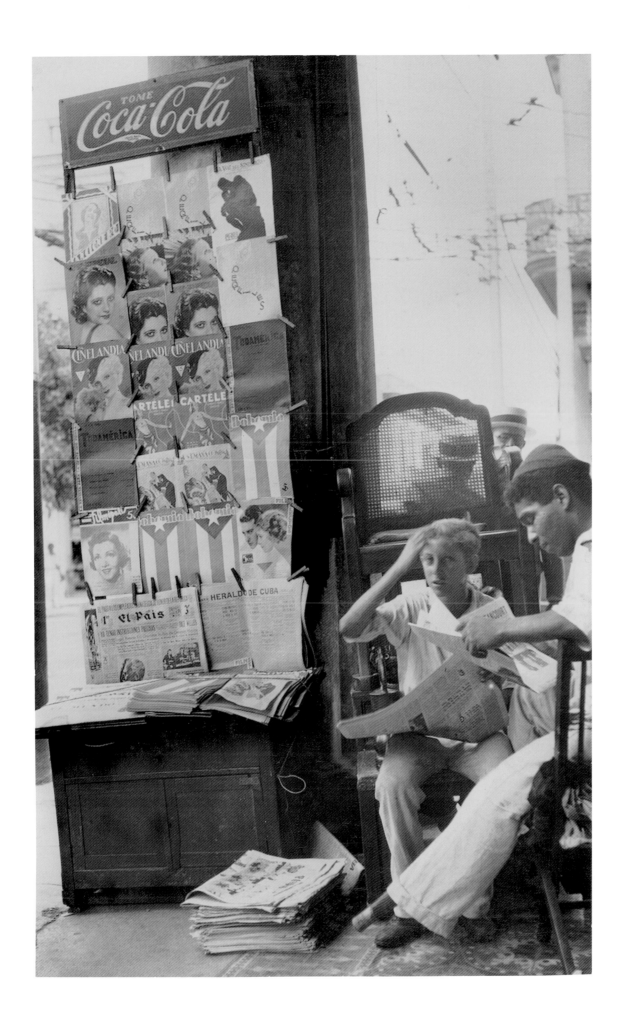

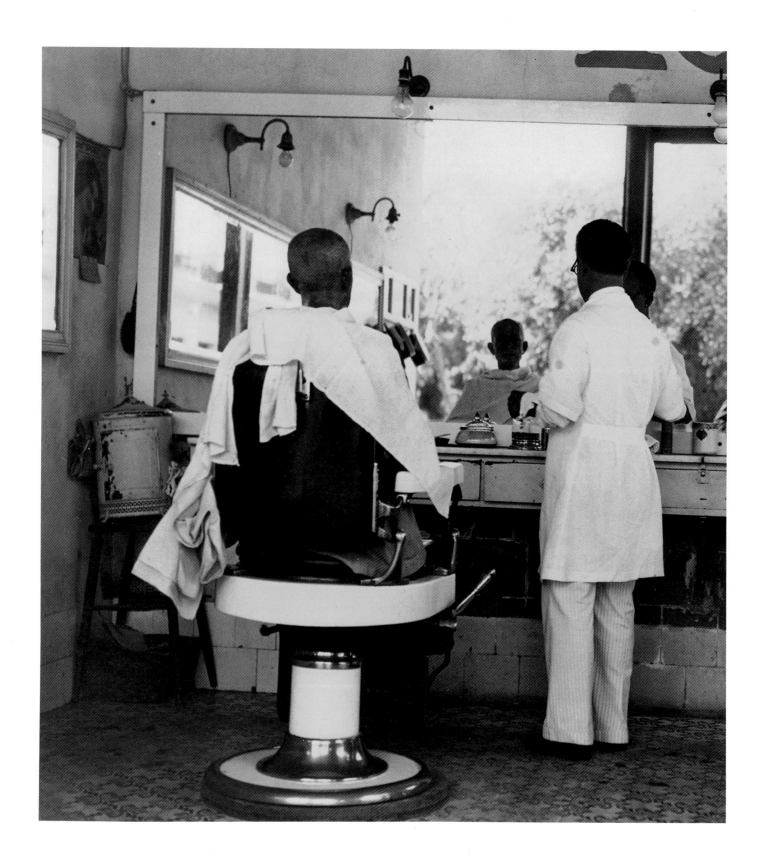

Plate 26. *Havana Barbershop*

Plate 27. *Havana Peddler*

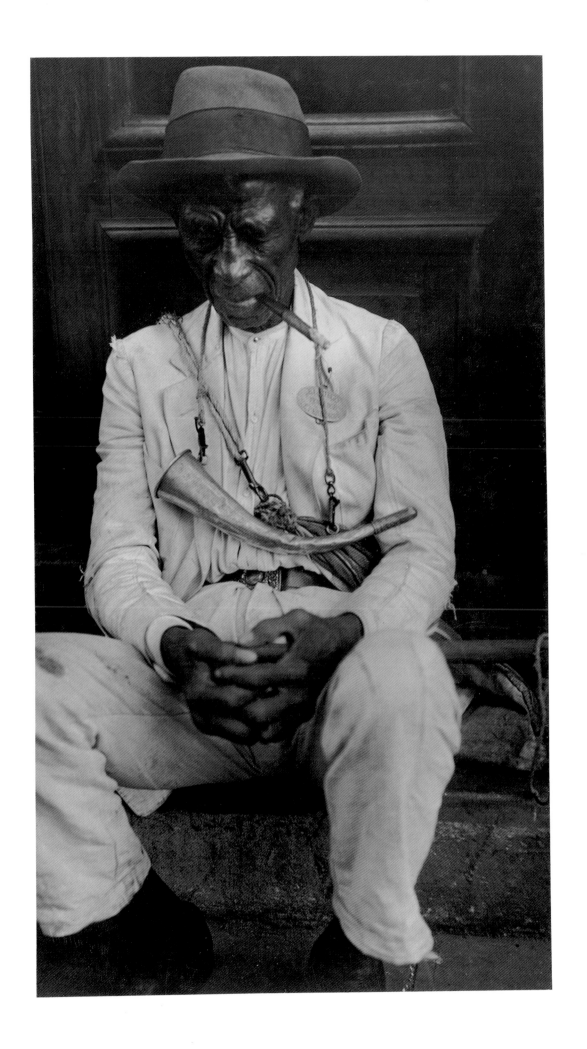

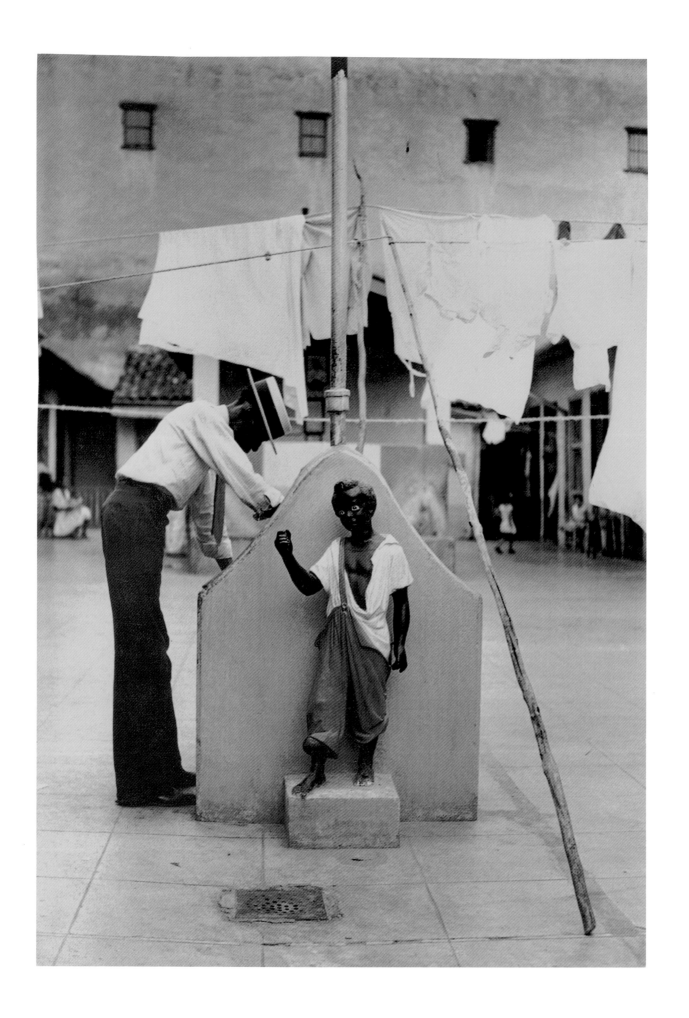

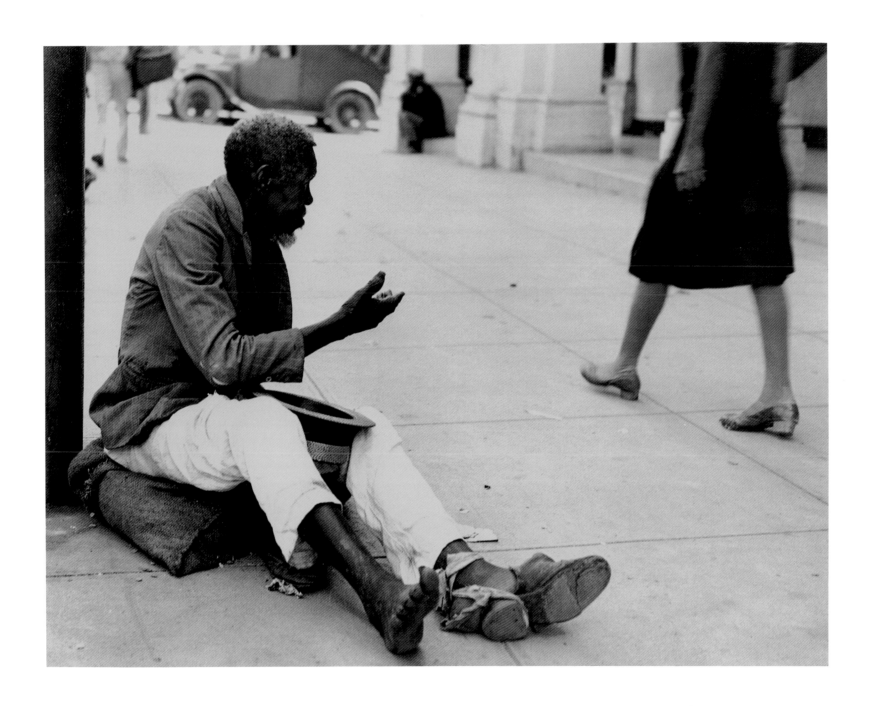

Plate 28. *Havana Courtyard* Plate 29. *Beggar*

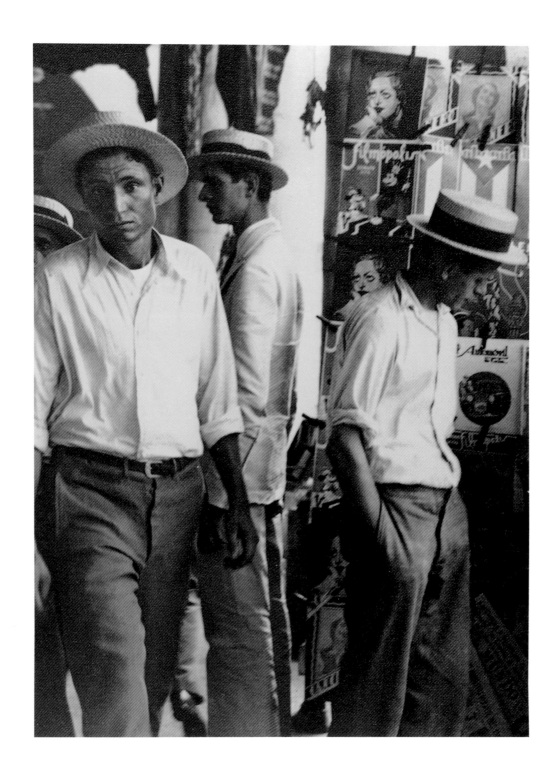

Plate 30. *People in Downtown Havana*

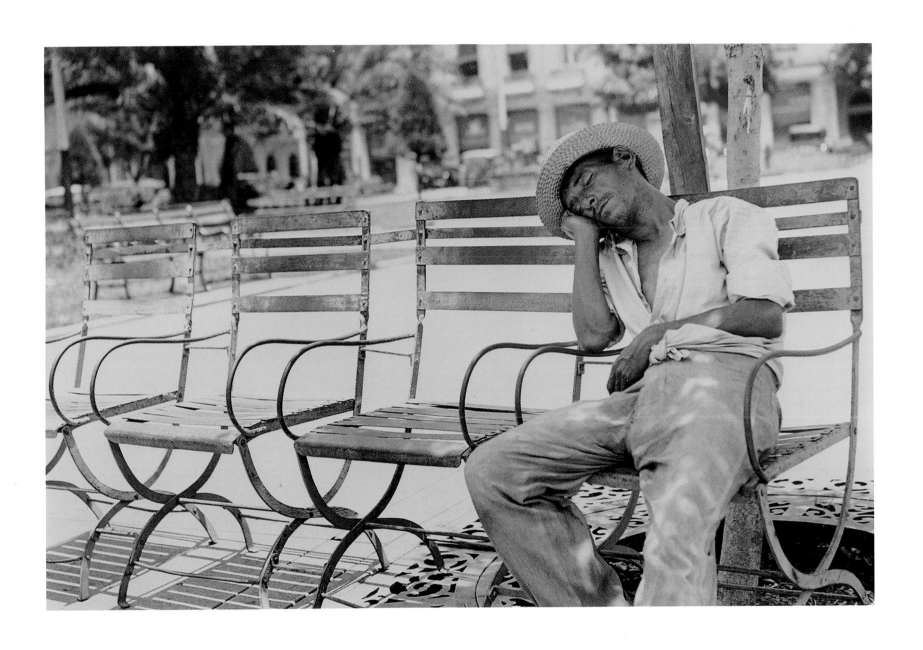

Plate 31. *Parque Central II*

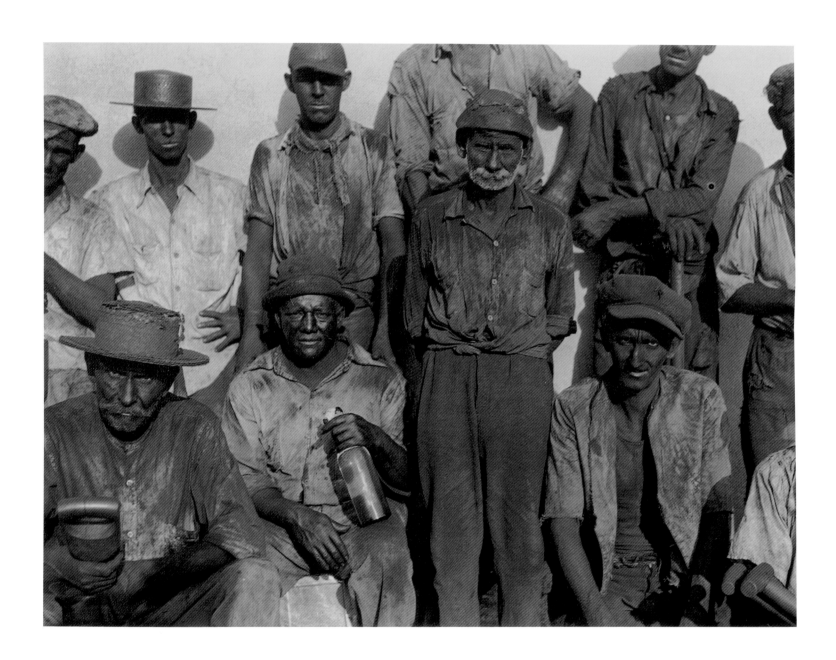

Plate 32. *Coal Dockworkers, Havana*

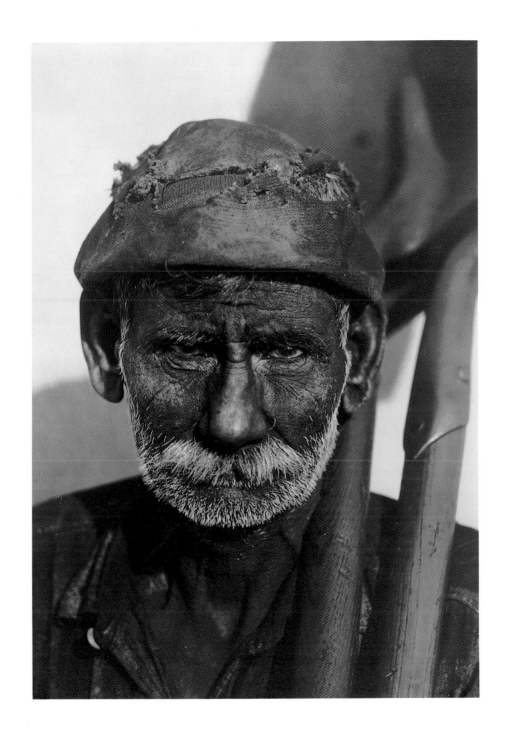

Plate 33. *Coal Loader, Havana*

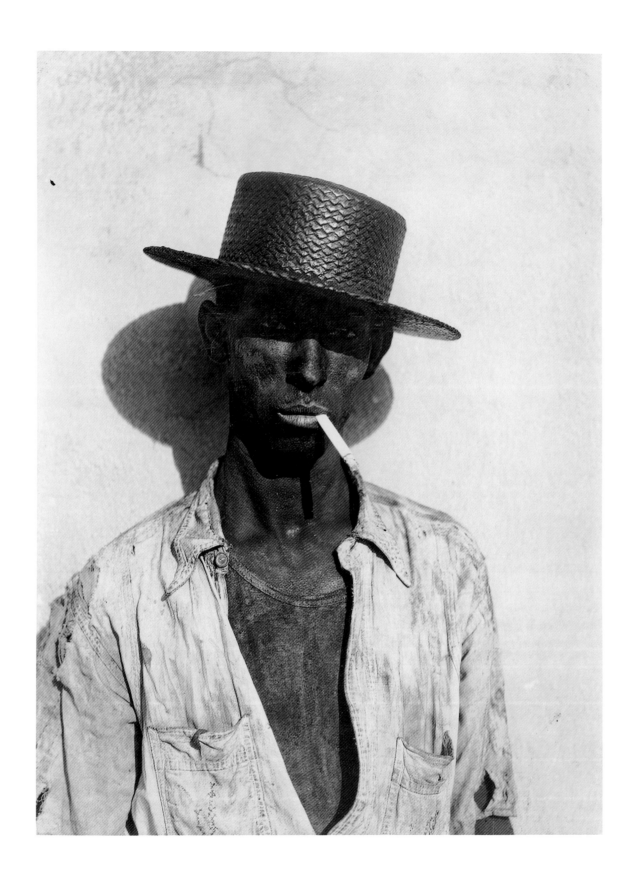

Plate 34. *Coal Stevedore, Havana* Plate 35. *Havana Stevedore*

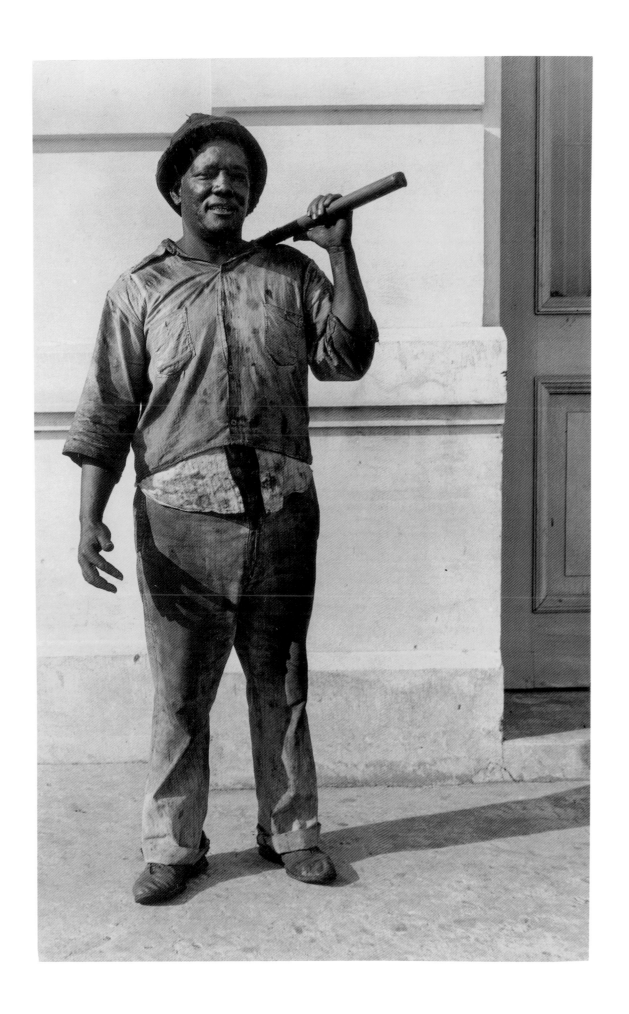

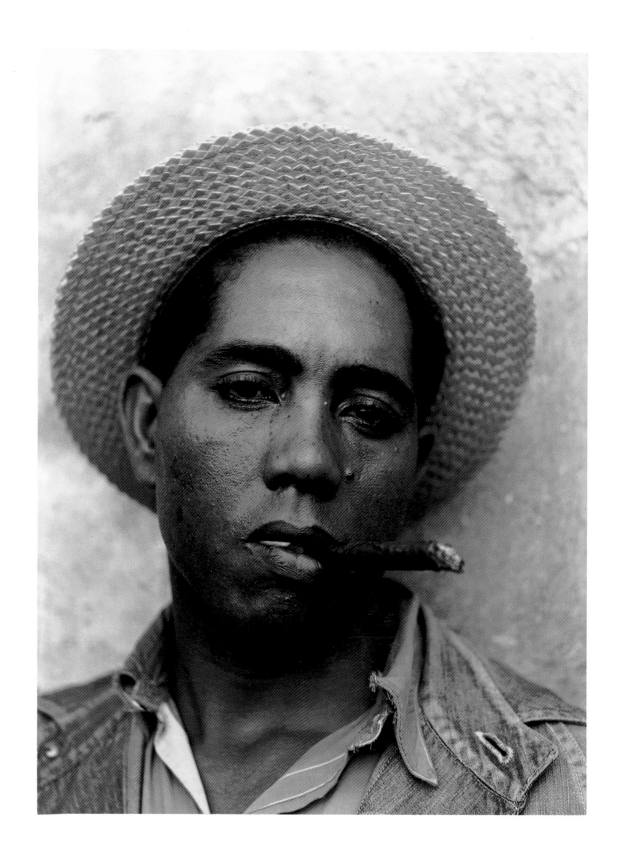

Plate 36. *Stevedore*

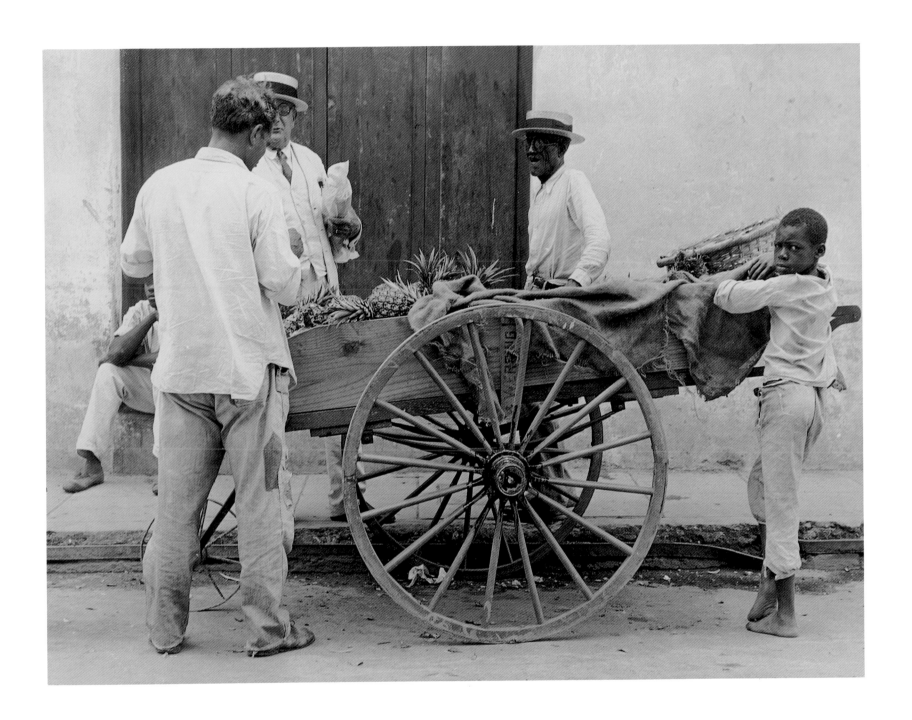

Plate 37. *Havana Street Vendors*

Plate 38. *Cuban Small Town Doorway*

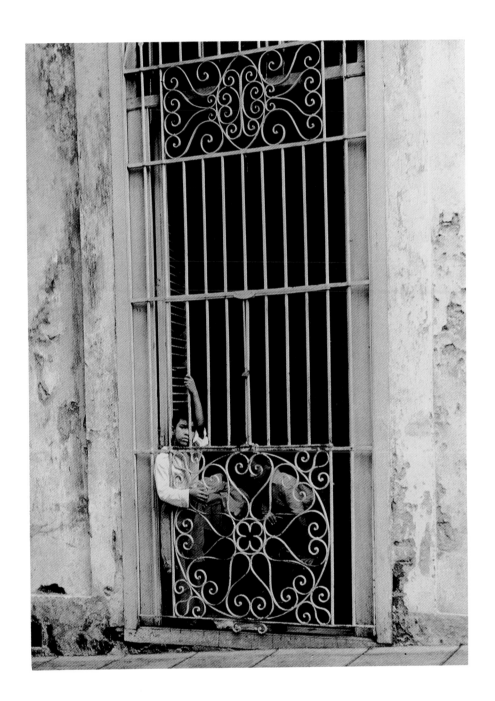

Plate 39. *Cuban Children*

Plate 40. *Two Cuban Doorways*

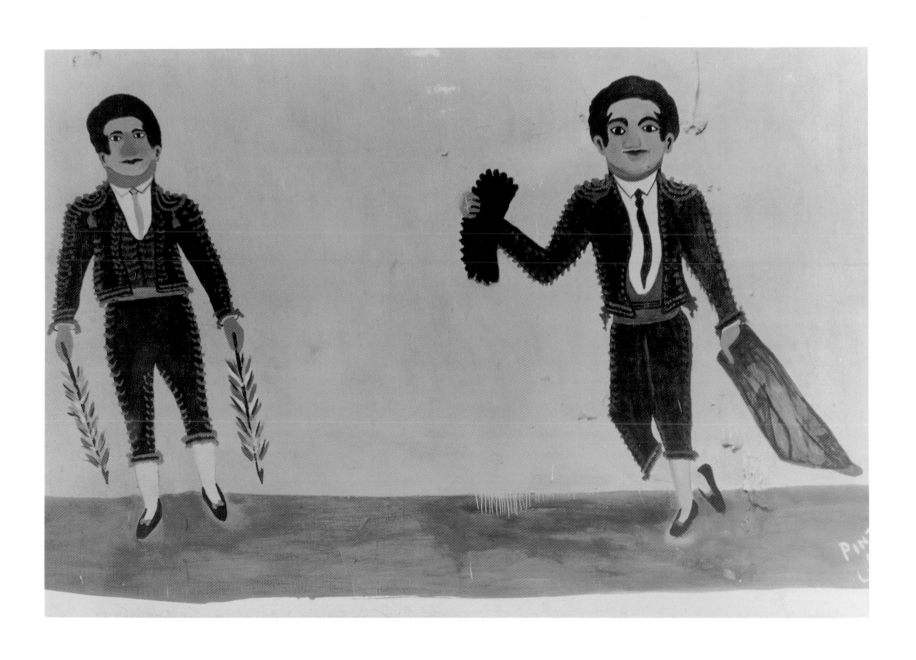

Plate 41. *Picador and Matador Mural by Adolfo Gálvez*

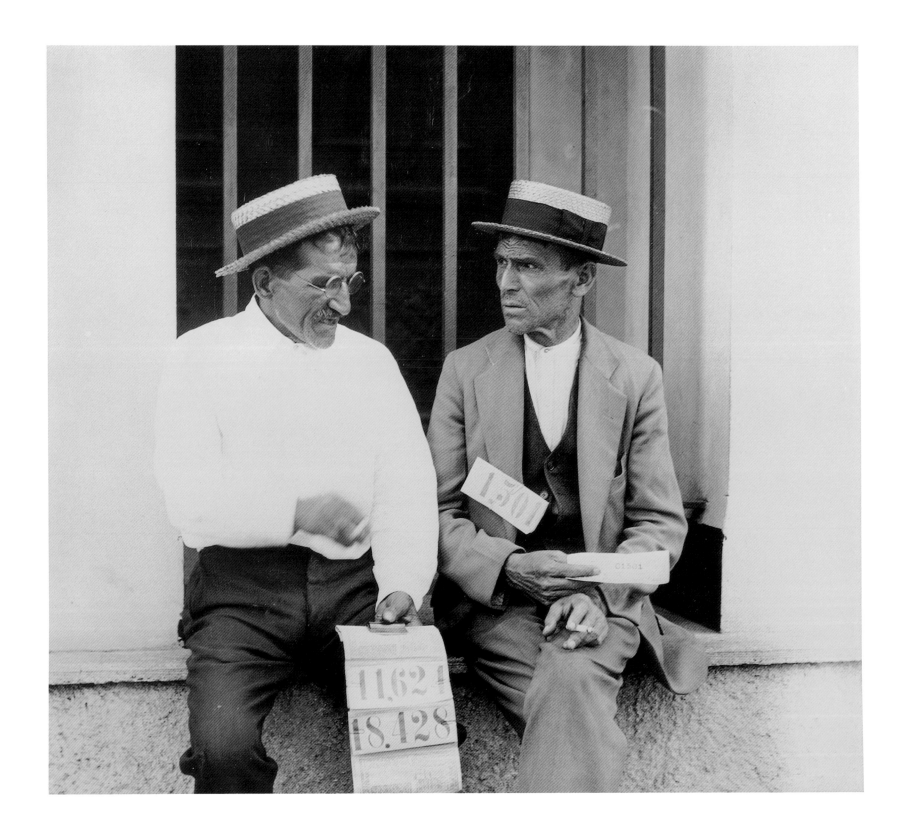

Plate 42. *Lottery Ticket Vendors*

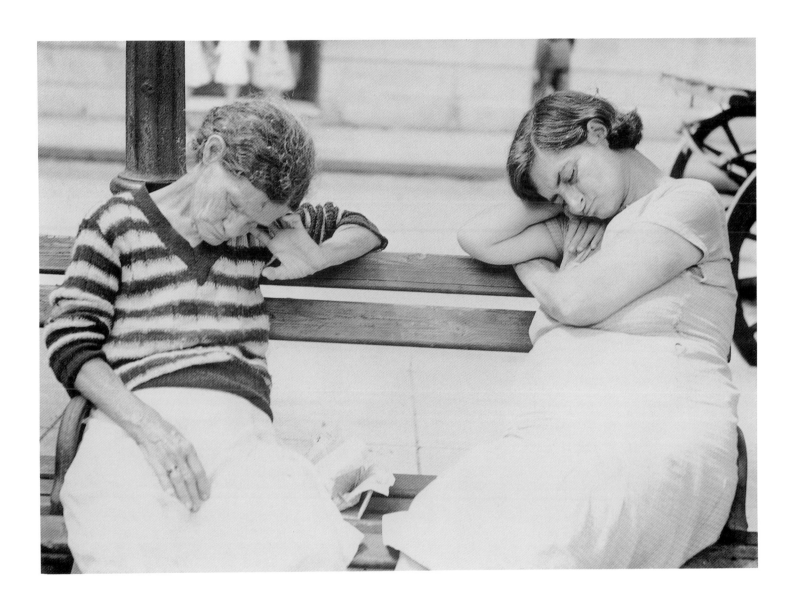

Plate 43. *Two Women Sleeping on a Havana Park Bench*

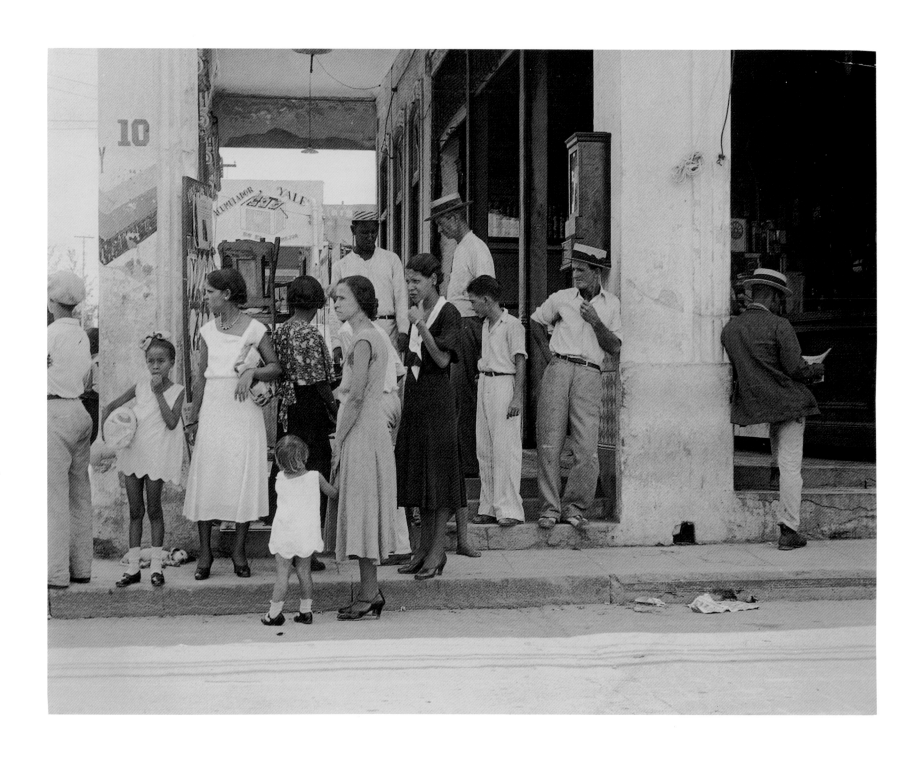

Plate 44. *City People*

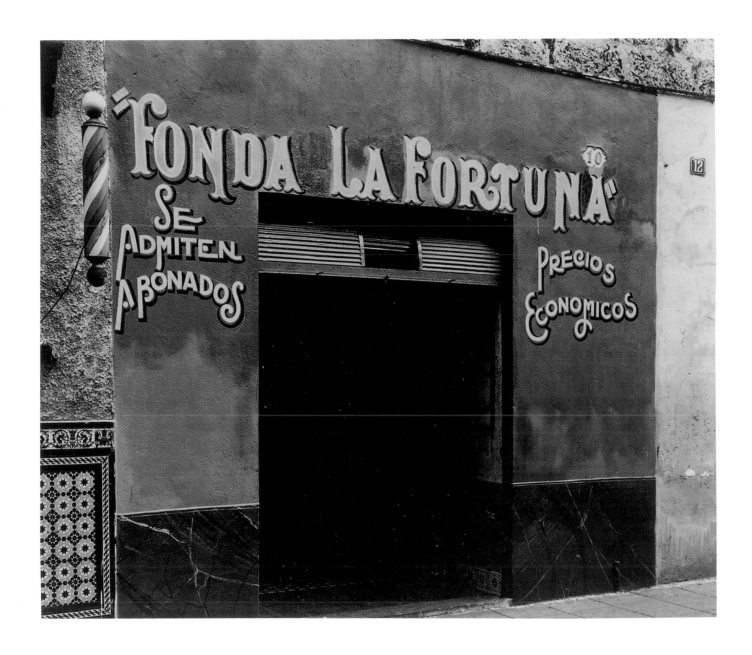

Plate 45. *Small Restaurant, Havana*

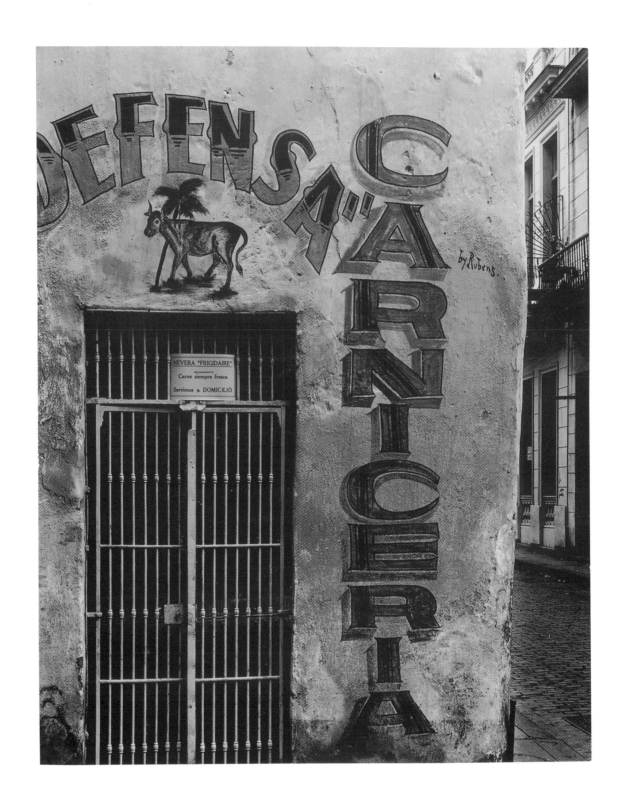

Plate 46. *Butcher Shop*

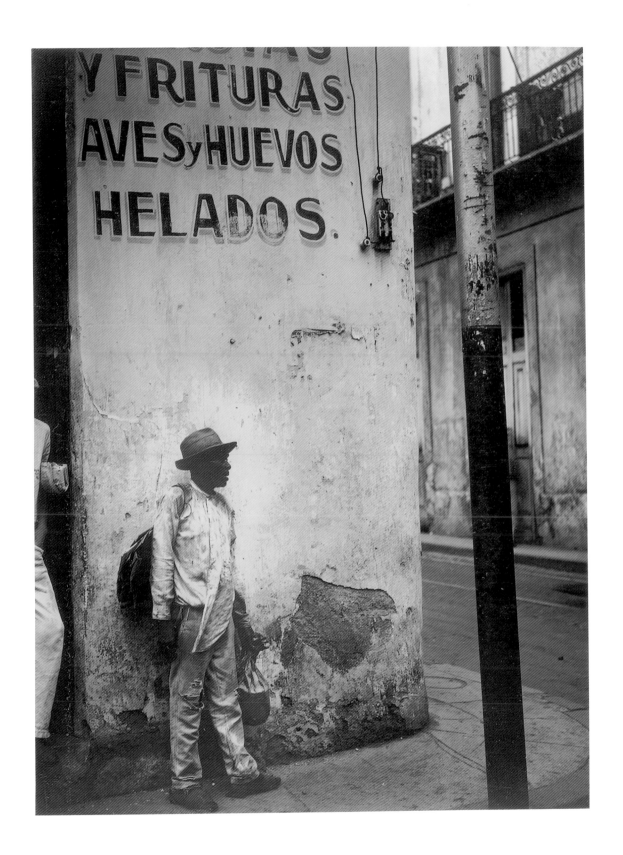

Plate 47. *Havana Corner*

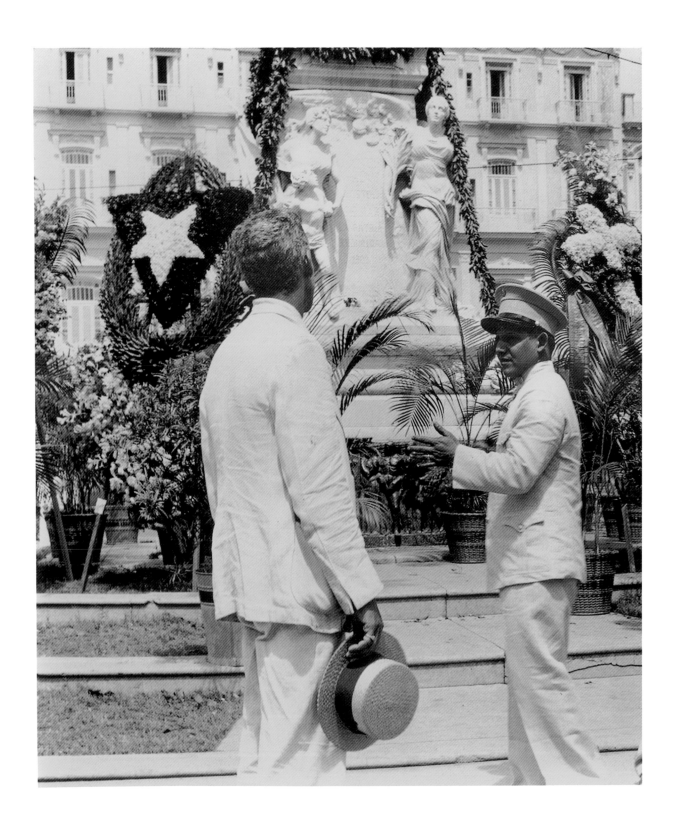

Plate 48. *Wreathlaying, Havana*

Plate 49. *Streetcar, Havana*

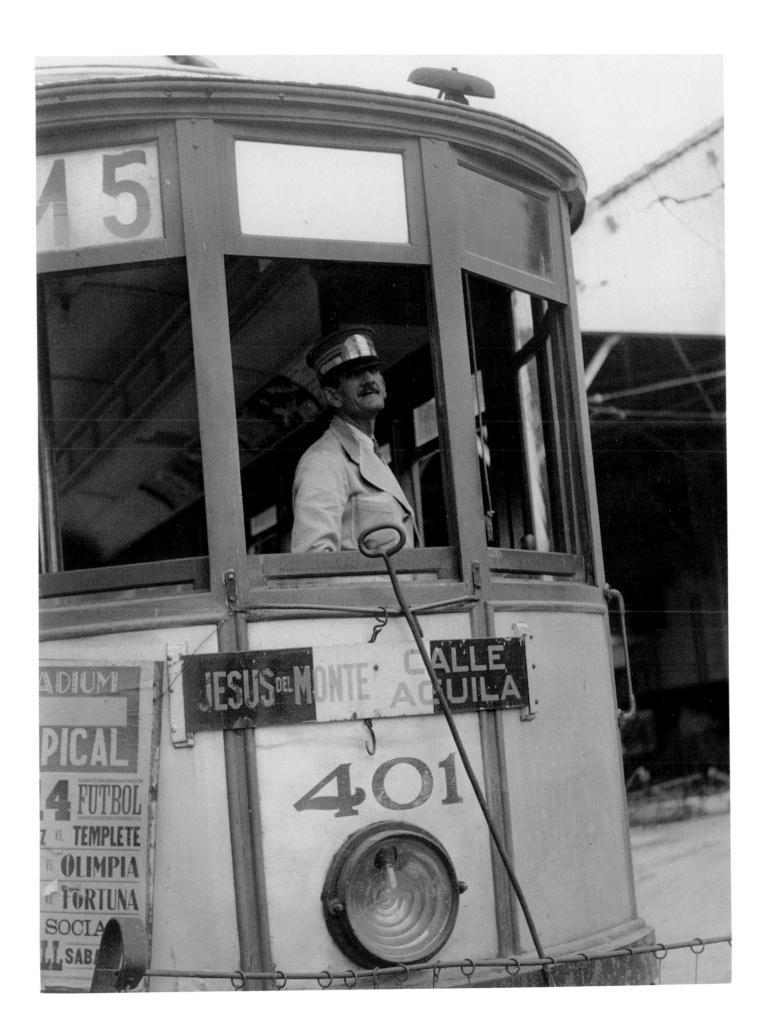

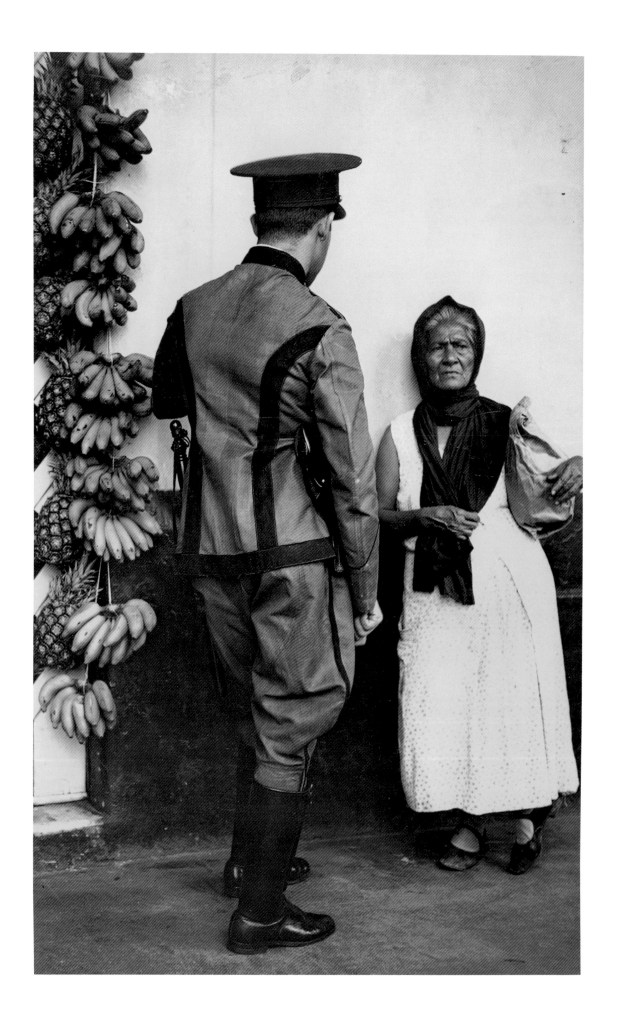

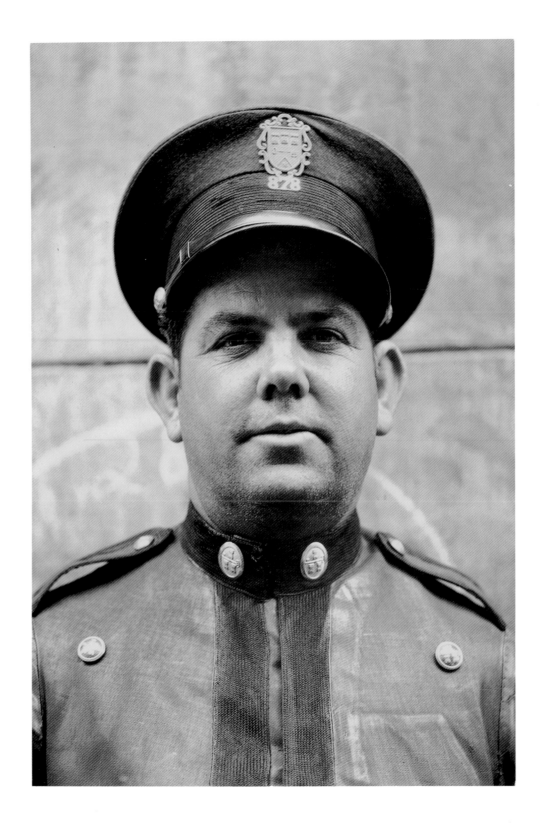

Plate 50. *Havana Policeman*

Plate 51. *Havana Policeman*

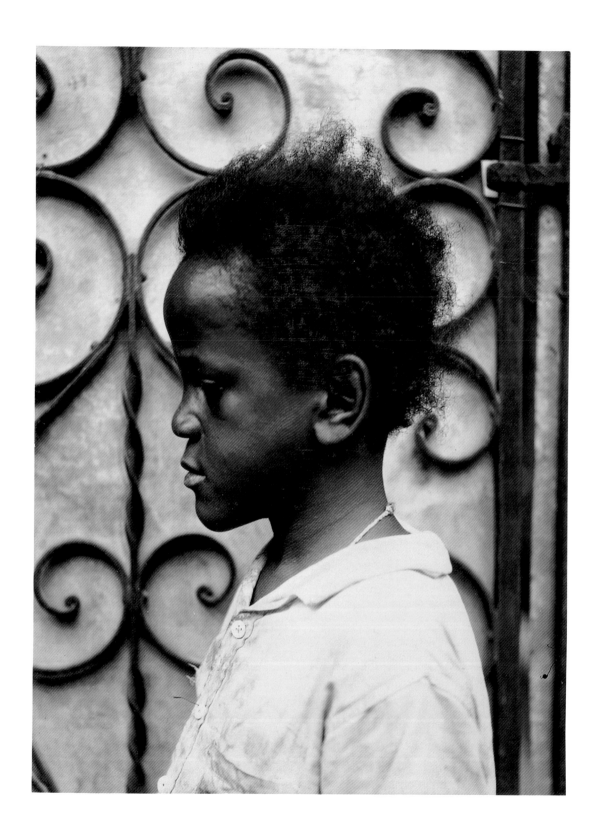

Plate 52. *Negro Child, Havana*

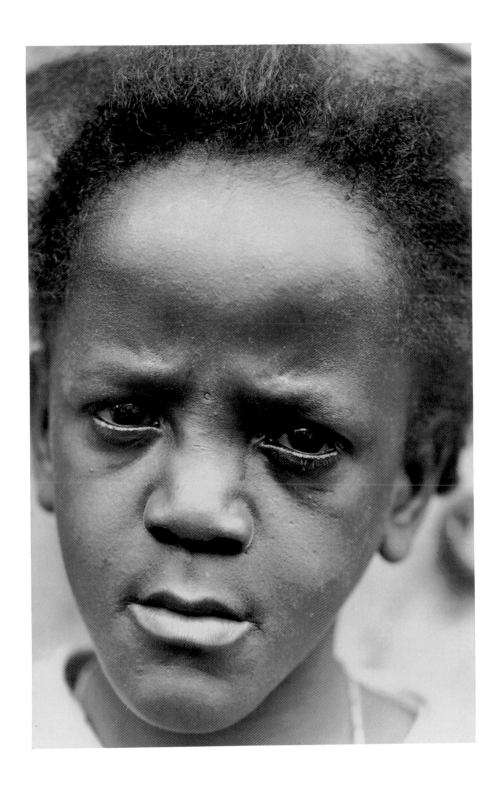

Plate 53. *Negro Child, Havana*

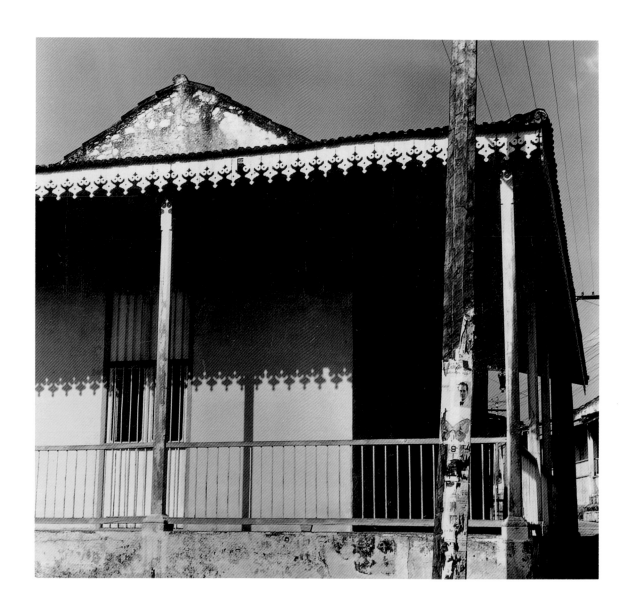

Plate 54. *House, Regla, Cuba*

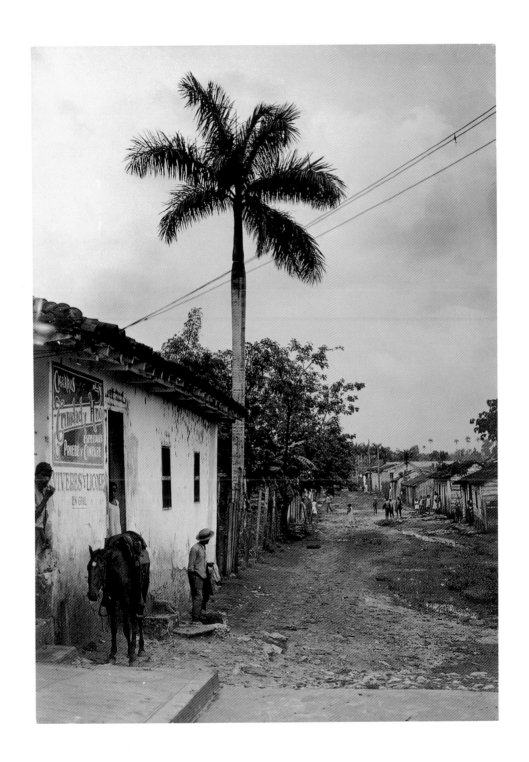

Plate 55. *Typical Town, Interior of Cuba*

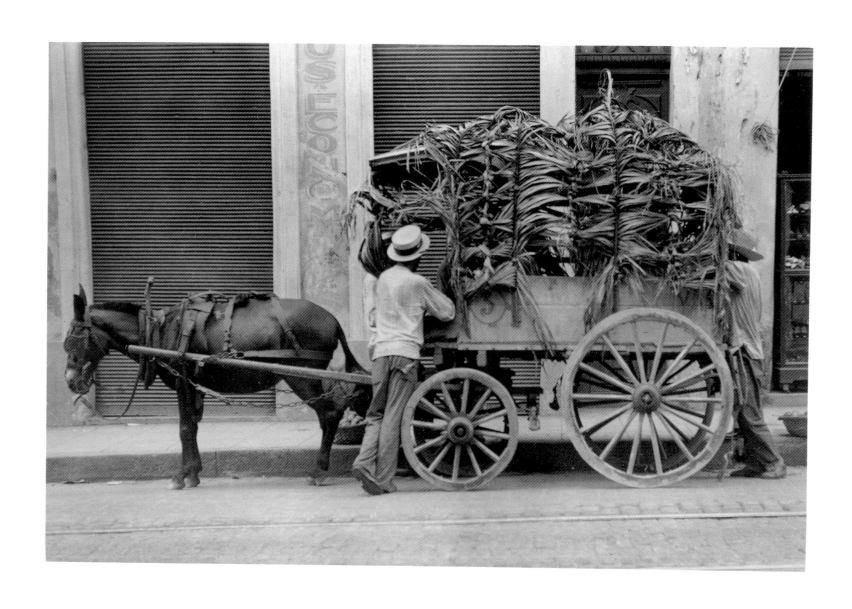

Plate 56. *Mule, Wagon, and Two Men, Havana*

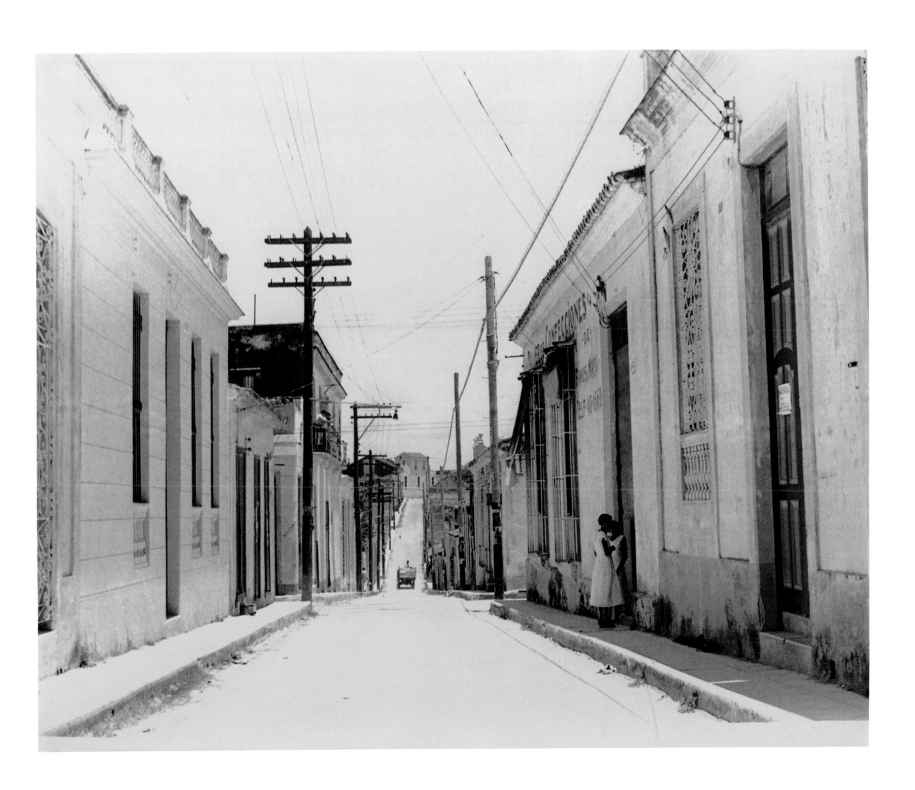

Plate 57. *Small Town*

Plate 58. *Outdoor Wall Advertisement, Rural Cuba*

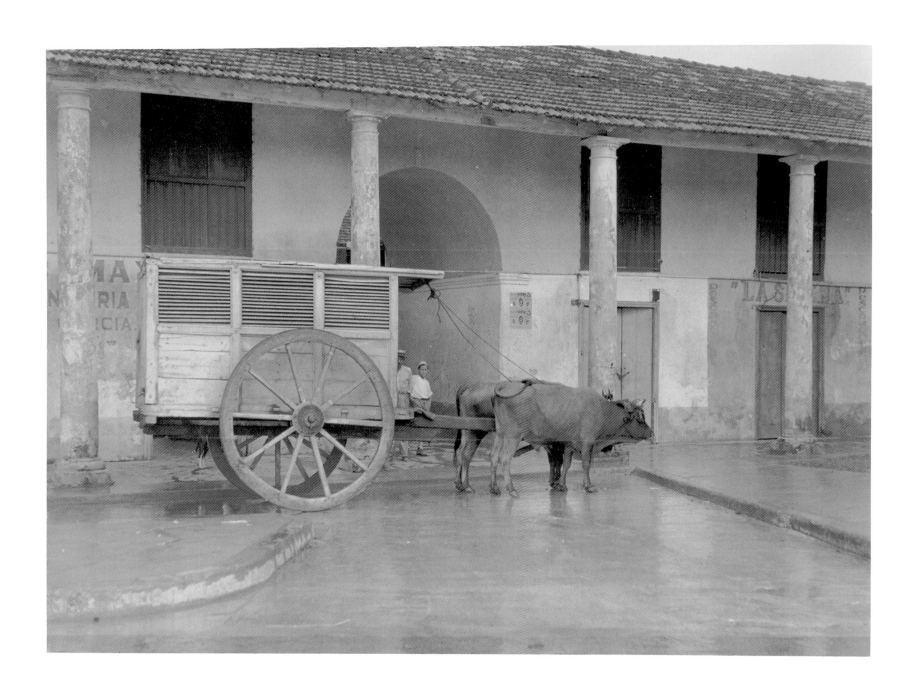

Plate 59. *Cuban Village*

Plate 60. *Central Conchita, Wall Painting by Adolfo Gálvez*

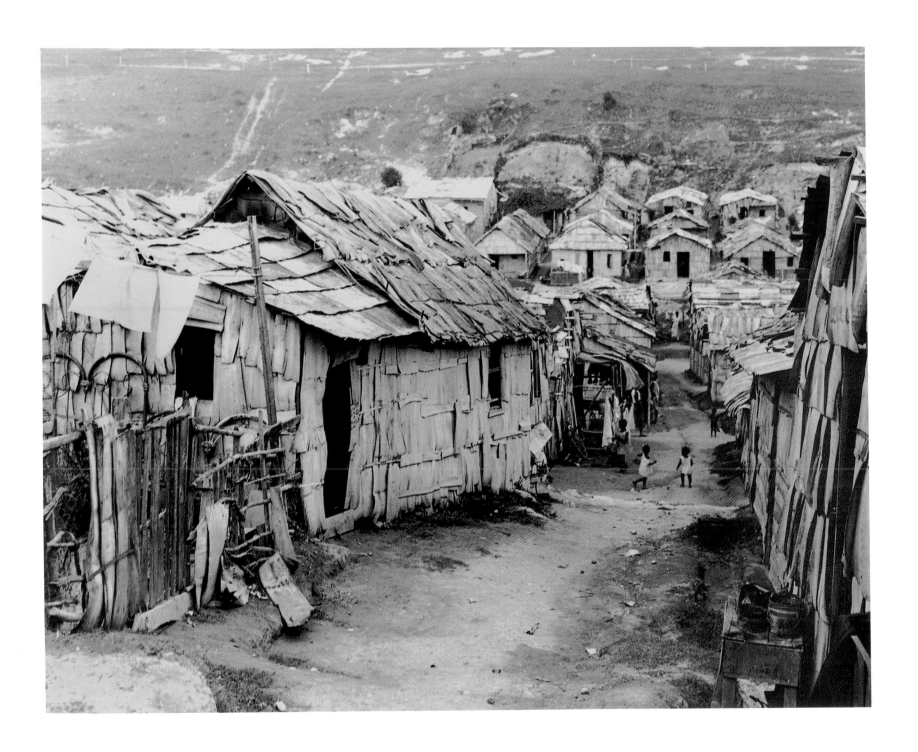

Plate 61. *Village of Havana Poor*

THE PHOTOGRAPHS

All photographs are gelatin silver prints. The negatives and prints were made in 1933.

1. *Roast Pork, Country Style (Self-Portrait)*
9 15/16 x 6 3/16 in.
84.XM.956.219

2. *View of Havana (Plaza del Vapor, Market Area)*
5 5/8 x 9 9/32 in.
84.XM.956.278

3. *Interior of Plaza del Vapor*
4 17/32 x 7 5/16 in.
84.XM.956.184

4. *Balcony Spectators, Detail*
4 x 6 1/16 in.
84.XM.956.160

5. *Cuban Religious Shrine*
7 13/32 x 4 15/32 in.
84.XM.956.216

6. *Cinema*
5 11/16 x 6 7/8 in.
84.XM.956.158

7. *Colonnade Shop, Havana*
6 11/16 x 9 5/16 in.
84.XM.956.266

8. *Havana Shopfront*
5 27/32 x 9 5/32 in.
84.XM.956.189

9. *Doorway with Hanging Pots, Kitchenware Shop, Havana*
9 1/4 x 6 1/2 in.
84.XM.956.148

10. *Cuban Courtyard Kitchen*
9 1/16 x 5 7/8 in.
84.XM.956.270

11. *Old Havana Housefronts*
6 15/16 x 8 15/16 in.
84.XM.956.258

12. *Public Spectacle*
6 7/8 x 9 3/16 in.
84.XM.956.156

13. *Spectacle, Capitol Steps, Possibly Independence Day, May 20*
7 3/4 x 9 31/32 in.
84.XM.956.231

14. *Havana Street*
9 1/4 x 6 1/4 in.
84.XM.956.152

15. *Havana Cinema*
5 13/16 x 9 1/4 in.
84.XM.956.142

16. *Wallwriting. We Support the Strike of the Cigar Workers. Down with the Imperialist War.*
5 3/4 x 9 3/16 in.
84.XM.956.162

17. *Woman and Children*
2 15/16 x 5 3/4 in.
84.XM.956.260

18. *Havana Country Family*
7 x 8 7/8 in.
84.XM.956.239

19. *Cuban Breadline*
5 15/16 x 9 3/32 in.
84.XM.956.237

20. *Woman on the Street, Havana*
9 11/16 x 5 3/4 in.
84.XM.956.145

21. *Courtyard in Havana*
7 3/4 x 5 13/16 in.
84.XM.956.265

22. *Woman in a Courtyard*
9 31/32 x 6 3/8 in.
84.XM.956.196

23. *Citizen in Downtown Havana*
8 3/4 x 4 5/8 in.
84.XM.956.484

24. *Bootblack Stand, Havana*
8 31/32 x 5 3/8 in.
84.XM.956.210

25. *Havana Shopping District*
9 5/8 x 6 3/32 in.
84.XM.956.215

26. *Havana Barbershop*
7 15/16 x 7 11/32 in.
84.XM.956.323

27. *Havana Peddler*
9 11/16 x 5 9/16 in.
84.XM.956.183

28. *Havana Courtyard*
9 9/16 x 6 23/32 in.
84.XM.956.268

29. *Beggar*
7 3/16 x 9 13/32 in.
84.XM.956.273

30. *People in Downtown Havana*
7 1/8 x 5 5/16 in.
84.XM.956.226

31. *Parque Central II*
5 15/16 x 9 1/16 in.
84.XM.956.166

32. *Coal Dockworkers, Havana*
6 1/8 x 8 5/16 in.
84.XM.956.167

33. *Coal Loader, Havana*
6 3/4 x 4 13/16 in.
84.XM.956.474

34. *Coal Stevedore, Havana*
7 15/16 x 6 in.
84.XM.956.242

35. *Havana Stevedore*
9 3/8 x 6 1/16 in.
84.XM.956.263

36. *Stevedore*
7 29/32 x 5 15/16 in.
84.XM.956.243

37. *Havana Street Vendors*
6 29/32 x 9 9/32 in.
84.XM.956.230

38. *Cuban Small Town Doorway*
5 x 5 in.
84.XM.956.208

39. *Cuban Children*
8 7/8 x 6 1/2 in.
84.XM.956.144

40. *Two Cuban Doorways*
6 1/16 x 7 17/32 in.
84.XM.956.221

41. *Picador and Matador Mural
by Adolfo Gálvez*
6 1/8 x 9 1/4 in.
84.XM.956.199

42. *Lottery Ticket Vendors*
7 11/16 x 8 3/4 in.
84.XM.956.157

43. *Two Women Sleeping on a Havana
Park Bench*
5 7/16 x 7 11/16 in.
84.XM.956.161

44. *City People*
6 31/32 x 9 1/32 in.
84.XM.956.244

45. *Small Restaurant, Havana*
6 1/32 x 7 11/32 in.
84.XM.956.261

46. *Butcher Shop*
7 1/2 x 6 1/16 in.
84.XM.956.141

47. *Havana Corner*
7 7/8 x 5 31/32 in.
84.XM.956.262

48. *Wreathlaying, Havana*
5 7/8 x 7 5/8 in.
84.XM.956.155

49. *Streetcar, Havana*
9 3/4 x 7 17/32 in.
84.XM.956.271

50. *Havana Policeman*
9 5/8 x 6 1/32 in.
84.XM.956.227

51. *Havana Policeman*
7 11/16 x 5 7/32 in.
84.XM.956.465

52. *Negro Child, Havana*
7 11/16 x 5 13/16 in.
84.XM.956.147

53. *Negro Child, Havana*
7 13/16 x 5 3/16 in.
84.XM.956.269

54. *House, Regla, Cuba*
5 13/16 x 5 29/32 in.
84.XM.956.224

55. *Typical Town, Interior of Cuba*
6 31/32 x 4 31/32 in.
84.XM.956.252

56. *Mule, Wagon, and Two Men, Havana*
5 7/16 x 8 9/32 in.
84.XM.956.247

57. *Small Town*
8 x 9 15/16 in.
84.XM.956.151

58. *Outdoor Wall Advertisement,
Rural Cuba*
7 1/2 x 6 in.
2000.57

59. *Cuban Village*
6 1/2 x 9 1/4 in.
84.XM.956.272

60. *Central Conchita, Wall Painting
by Adolfo Gálvez*
4 3/4 x 7 7/16 in.
84.XM.956.140

61. *Village of Havana Poor*
7 15/16 x 9 11/16 in.
84.XM.956.277

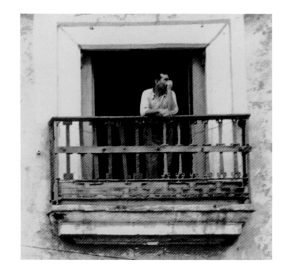

Library of Congress Cataloging-in-Publication Data

Evans, Walker, 1903–1975.
 Walker Evans, Cuba / with an essay by Andrei
Codrescu ;
 introduction by Judith Keller.
 p. cm.
 ISBN 0-89236-617-6
 1. Cuba–Pictorial works. 2.Cuba–History–1909-
1933–Pictorial works. 3. Evans, Walker,
1903-1975–Aesthetics. 4. J. Paul Getty Museum.
5. Photograph collections–California–Los
Angeles. I. Codrescu, Andrei, 1946-
II. J. Paul Getty Museum. III. Title.
 F1787 .E86 2001
 972.9106'3–dc21 2001000541
 CIP

© 2001 The J. Paul Getty Trust

Getty Publications
1200 Getty Center Drive
Suite 500
Los Angeles, California 90049-1682

www.getty.edu

Publisher
Christopher Hudson

Editor-in-Chief
Mark Greenberg

Project Staff

Editor
John Harris

Designer
Kurt Hauser

Production Coordinators
Anita Keys
Stacy Miyagawa

Photographer
Ellen M. Rosenbery

Research Associate in the Department of
Photographs
Michael Hargraves

Printed in Italy by Artegrafica

Front cover: Detail of *Woman on the Street, Havana*
(pl. 20).

P. 1: Detail of *Typical Town, Interior of Cuba* (pl. 55).

Pp. 2, 3: Detail of *Coal Dockworkers, Havana* (pl. 32).

Frontispiece: Detail of *Citizen in Downtown Havana*
(pl. 23).

This page: Detail of *Old Havana Housefronts* (pl. 11).

DATE DUE
